GHOSTS OF
BOSTON

GHOSTS OF BOSTON
HAUNTS OF THE HUB

SAM BALTRUSIS

Published by Haunted America
A Division of The History Press
Charleston, SC 29403
www.historypress.net

Cover image: Beacon Hill's Acorn Street, known as one of the most photographed spots in America thanks to its picturesque brownstones and narrow cobblestone lane dating back to the 1820s, is also rumored to be Boston's most haunted. There have been numerous sightings of ghostly, full-bodied apparitions wearing turn-of-the-century and Civil War–era garb passing by the street's ornate, gaslit lamps. *Photo by Ryan Miner.*

First published 2012

Manufactured in the United States

ISBN 978.1.60949.742.2

Library of Congress CIP data applied for.

CONTENTS

ACKNOWLEDGEMENTS

I would like to thank Andrew Warburton, my eagle-eyed Agent Scully and research assistant, who believed in this monstrous project from the beginning. Special thanks to the handful of paranormal investigators and researchers who helped make *Ghosts of Boston* a reality, including Adam Berry from *Ghost Hunters*, Jeffrey Doucette and Hillary Kidd from Haunted Boston, Scott Trainito and Mike Baker from Para-Boston, Wendy Reardon from Gypsy Rose Pole Dancing, Christina Zamon from Emerson's library archives and Jim Lauletta for his comedic ghost-hunting talents. Special thanks to my writing colleagues, including Scott Kearnan from *STUFF* magazine, who published the initial "Haunted Hot Spots" article; James Lopata from *Boston Spirit*; Stephanie Schorow, who coauthored *The Boston Mob Guide* and helped navigate The History Press landscape; and my former high school journalism teacher and mentor, Beverly Daniels Reinschmidt. Thanks to my mother, Deborah Hughes Dutcher, for her support even after I came out of the paranormal closet, and my friend Joe Keville for showing me the light when I was surrounded by darkness. The book's back-cover illustrator, Dan Blakeslee, and photographer, Ryan Miner, deserve a special shout-out for working the graveyard shift. I would also like to thank Jeff Saraceno from The History Press for his understanding approach to *dead*lines and his support during the process of putting this book together.

INTRODUCTION

I see dead people. At least, that's what the headline of a popular Boston-based blog called "Universal Hub" reported after I posted a picture online after one of my eerie close encounters of the poltergeist kind. My run-in happened one winter afternoon outside the last stop on the Orange Line T station in Jamaica Plain near the Forest Hills Cemetery. The ghostly figure, a shorter-than-usual specter that looked like the outline of a child peeking out of an open Forest Hills station subway door, manifested itself during one of my impromptu photo shoots for a freelance project.

As a recovering *X-Files* junkie, I've always been more of an Agent Scully than David Duchovny's Mulder. However, after a string of unexplained paranormal encounters over the years, I must admit that I've become more of a believer than a skeptic. However, I've approached *Ghosts of Boston* as a journalist and left no gravestone unturned when it came to digging up the historical dirt on each so-called haunting.

Since that subway incident, I've spent years investigating alleged accounts of paranormal activity at sites all over Boston. I've collected a slew of reports from these supposedly haunted locales, and the mission was to give readers a contemporary take on Boston's bevy of site-specific legends. *Ghosts of Boston* is, in essence, a supernatural-themed travel guide written with a historical lens. Based on my research, the city is a hotbed of paranormal activity.

Incidentally, I have firsthand experience with many of the haunts in the book. For example, my old sophomore-year dormitory at Boston University, the fourth-floor Writers' Corridor at Shelton Hall, is rumored to be haunted

by Pulitzer Prize winner Eugene O'Neill. Did I have a close encounter with the phantom playwright? Not exactly. But I do remember flickering lights and inexplicable knocks when no one was there. The old hotel's ambiance was eerie and it always exuded a haunted vibe, but I didn't experience anything supernatural.

However, my first spirited encounter occurred while living in Somerville during the early 1990s. I remember seeing an apparition of a young girl who would play hide-and-seek in the hallway. She was a mischievous poltergeist, and I remember hearing phantom footsteps leading up to our second-floor apartment.

My personal experiences with the paranormal have been sporadic over the years. I do recall spotting a see-through residual spirit of a Confederate soldier when I worked for an alternative newsweekly in Pensacola, Florida. He would appear in the early evening, holding a Civil War–era sword, and pass through the back entrance of the building. It was like a videotaped replay of a traumatic event that occurred years ago.

In 2007, I moved back to Boston and had an experience while touring the ramparts of Fort Warren at Georges Island. Out of the corner of my eye, I noticed a female figure dressed in black. I looked again, and she was gone. At this point, I had never heard of the Lady in Black legend. I just intuitively knew Georges Island had some sort of psychic residue. While researching Fort Warren's back story, my interest in Boston's haunted past slowly started to become a passion. History repeats itself, and it was my job to uncover the truth and give a voice to those without a voice—even though most of the stories turned out to be tales from the crypt.

While researching a Halloween-themed story called "Haunted Hot Spots" for *STUFF* magazine, I started spending hours in the Boston Common. I've always felt a strong magnetic pull to the site of the Great Elm, also known as the hanging tree. I also had an inexplicable interest in the Central Burying Ground, and one night while walking by the old cemetery, I noticed a young female figure wearing what looked like a hospital gown and standing by a tree. I looked back and she was gone. At this point, I didn't know about the Matthew Rutger legend dating back to the 1970s. Like me, he saw a ghost at the old cemetery, and I remember shivering in the beauty and the madness of the moment. Somehow, I felt her pain.

A few months after the incident, I joined the team at Haunted Boston, a group of tour guides who specialize in telling Boston's paranormal history, and learned about many of the so-called ghosts from New England's not-so-Puritanical past. While giving tours, I had several encounters with the

paranormal at the Omni Parker House. Over the years, I've stayed away from the hotel because it had a mysterious, something-wicked-this-way-comes vibe to it from the outside. While taking a photo in front of the famed "enchanted mirror" on the second-floor mezzanine, I noticed condensation mysteriously appear on the mirror as if someone, or something, was breathing on it. According to hotel lore, the antique was taken from Charles Dickens's room, and he apparently stood in front of it to practice his nineteenth-century orations. As a special treat for guests on my tour, I guide them to the supernatural hot spot. While the ghost story is intriguing, what interested me more is that the press room next to the creepy mirror is where John F. Kennedy announced his candidacy for president. I've seen tons of photos and heard many stories from patrons who had strange encounters while staying on the hotel's upper floors. Today, the Omni Parker House has become one of my favorite hot spots in the city. Haunted history oozes from the oldest continuously operating hotel in the country.

While writing *Ghosts of Boston*, I've uncovered some historical inaccuracies tied to a few of Boston's ghostly legends. For example, one of the college dormitory haunts, the "shaft girl" ghost at Emerson's The Little Building, was almost identical to the story told at the former "devilish dormitory" called Charlesgate. Incidentally, the girl who allegedly fell to her death in the elevator shaft didn't die tragically and ended up living a long, happy life. Many legends—like William Austin's Peter Rugg literary character, who stubbornly rode his horse into a thunderstorm in 1770 and was cursed to drive his carriage until the end of time—didn't exist. However, people over the years have reportedly spotted the ghostly man with his daughter by his side frantically trying to make the trek back to Boston.

For many, the only real ghosts that exist are the ones that haunt the insides of their heads.

One of my favorite stories in the book centers on the Para-Boston investigation at the abandoned Everett Square Theatre. The evidence uncovered in the write-up was based on scientific research. The crew recorded the sounds of footsteps and then what seemed like an inhale followed by a harsh exhale in the stairwell leading up to the building's projection room. When it comes to paranormal investigations, sometimes fact is stranger than fiction.

As far as my belief in the supernatural, I still haven't found what I'm looking for in regard to concrete proof. However, I do have a sensitivity to what could be the spirit realm. In fact, my new home in Davis Square apparently has a playful older female poltergeist with an affinity for scissors.

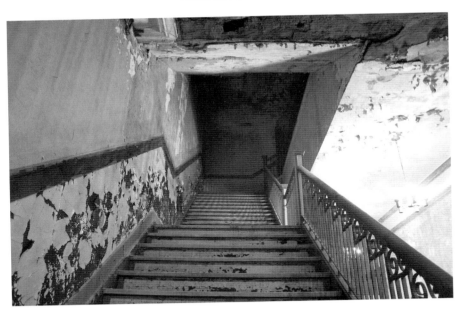

Investigators from Para-Boston recorded the sounds of footsteps and then what seemed like an inhale followed by a harsh exhale in the stairwell leading up to the projection room at the abandoned Everett Square Theatre, 16 Fairmont Avenue, in Hyde Park. *Courtesy of Mike Baker from the New England Center for the Advancement of Paranormal Science (NECAPS).*

One night, I invited a friend over who claimed to have some sort of psychic ability. He said that she was a seamstress during the Depression era and mentioned, without hesitation, the various things she did in the house to make her presence known.

While writing the book, an unseen force opened doors that were firmly shut. Lights mysteriously turned on and off without provocation. According to my roommate, scissors have disappeared and then reappeared over the years in the two-floor Gothic-decorated home. One night while I was writing into the wee hours on the Boston Harbor Islands' Lady in Black myth, I noticed a gray-haired female figure wearing an old-school white nightgown and donning fuzzy slippers dart across the first floor. I ran downstairs and noticed that the closet door had been mysteriously opened and the lights had been turned on while I was upstairs hacking away at my computer. My roommate was out of town. No one else was there.

Was it a spirit? Perhaps. I do know that somewhere deep in my subconscious, ghost stories satiate a primitive desire to know that life exists after death. I believe.

GHOST DIARIES

Based on my nationally televised stint as Boston's paranormal expert on the Biography Channel's *Ghostly Encounters*, spirits are serious business. The on-camera interview, which was shot in front of the Central Burying Ground and facing what I called Boston's "haunted corridor" near the corner of Boylston and Tremont Streets, explored the residual energy, or psychic imprint, left over from the 1897 gas-line explosion. The area surrounding the country's oldest underground subway station, the Boylston Street T stop, has been a hot spot of alleged paranormal activity. Why? Beneath what was a dead man dumping ground for British soldiers killed during the Revolutionary War is a series of vacated "ghost tunnels" that cuts through what was, in essence, a mass grave site. It's my belief that the residual hauntings are psychic remnants of the unjust killings and unmarked graves left over from three hundred years of blood-soaked dirt from Boston's not-so-Puritanical past.

The motley crew of paranormal personalities featured in the book's "Ghost Diaries" introduction helped fuel my journalistic drive to leave no gravestone unturned and gave a voice to the ghosts of Boston still lingering in the shadows of the historic city's haunted landscape.

ADAM BERRY, SYFY'S *GHOST HUNTERS*

Long before Adam Berry snagged top prize as a paranormal investigator in training on Syfy's *Ghost Hunters Academy*, he confronted a school spirit haunting his college dormitory. "I thought that I had a ghost in my dorm room at the Boston Conservatory during my junior year," Berry said, adding that he had felt a presence physically hold him down, a phenomenon known as sleep paralysis. "I was freaked out and thought there was something in my room. My mother told me to take some dirt from the front of my dorm and throw it in the cemetery. We did and dumped the dirt in the old cemetery near Emerson [Central Burying Ground] to get rid of the spirit," he remarked. "After that, I never felt intimidated being in that dorm."

As far as the ghost lore surrounding campus hauntings, Berry believes it's a rite of passage. "Going to college is like going to summer camp, but with classes," he mused. "You have stories that are told from generation to generation on a college campus. And universities like Harvard have dorms

Adam Berry, winner of Syfy's *Ghost Hunters Academy* and a noted paranormal investigator from *Ghost Hunters*, confronted a school spirit while studying at the Boston Conservatory and believes that the city is a hotbed of paranormal activity, thanks to its three-hundred-year-old history. *Courtesy of Adam Berry.*

that are hundreds of years old, so it makes sense that these spooky ghost stories continue to be told. Also, seniors love to scare freshmen."

Berry, who founded the Provincetown Paranormal Research Society (PPRS) in 2006 after graduating from college, said that his ghostly encounter in Boston, coupled with a supernatural experience in Gettysburg, Pennsylvania, helped fuel his interest in the spirit realm. "Boston is one of my favorite cities in the world and obviously has something going on," the twenty-nine-year-old said. "Because of the history, there are so many interesting places that could be investigated. It was one of the biggest seaports in the country and had tons of activity during the Revolutionary and Civil Wars. There must be spirits left behind, mulling about and checking out the status of the community they built way back when." During his four-year stint at the conservatory, the paranormal investigator, who is originally from Muscle Shoals, Alabama, said he fell in love with the Hub. "Boston's rich history and the singular fact that it was the cornerstone of the American Revolution makes it a city that is truly one of a kind," he said. "Why would anyone want to leave…even after they're dead?"

After studying in Boston, he moved to the Lower Cape. While living in Provincetown with his partner, Ben Griessmeyer, he would spend hours in old cemeteries armed with an EVP recorder before auditioning for *Ghost Hunters Academy* and then officially joining the TAPS (The Atlantic Paranormal Society) team. "Cemeteries have a lot of activity. The [spirits] want to talk to you, and they may have a story to pass on," he remarked. "As investigators, we try not to go by feelings, because you can't prove feelings. But you can't ignore your biggest organ, which is your skin and the goose bumps that you get and feeling like you're being watched."

Compared to his early investigations with the PPRS, Berry said he's raised the supernatural bar on *Ghost Hunters*. "Obviously, it's very professional now. When I was hanging out in Provincetown and doing investigations, it was very low-key and the stakes weren't as high," he explained. "We would go out into a cemetery or some place that was old and sit around with our recorders and wait to see what happened. Now, individuals call us in and the stakes are much higher. But it's still fun, and we get excited when something paranormal happens. Going into a new place is like opening a Christmas present or finding something brand-new that you really love."

When it comes to preconceived notions regarding paranormal investigations, Berry admitted that he had a few before joining the *Ghost Hunters* team. "The biggest misconception people have is that we go to these haunted locations and everything happens quick just like it is on

TV," he laughed. "Before working with TAPS, I've learned that ghost hunting is one of the most boring occupations around. I say that with all due respect, but you sit there for hours sometimes, in the dark, and nothing happens. You have to find ways to change up your questions, make it interesting and use tactics to get whatever that may be there to interact with you. People think we go to a haunted location, find evidence and then go home. No, sometimes we spend days at locations and nothing happens. But when we do find something, it's thrilling. It makes up for all the hours sitting in silence."

For those out of the pop-culture loop, Berry and the *Ghost Hunters* team check out locations reported to have paranormal phenomena, and its investigators use equipment and experience to try to uncover whether a place is actually haunted. Berry said he's become much more skeptical since joining the TAPS team. For example, most of the photos with so-called orbs that he sees from the show's fans are, in fact, light anomalies. "Most of the time it's just dust or insects," he explained. "The definition of an orb is a spherical object that produces its own light. So a real orb is created naturally by energy, or in theory, it's a spirit floating through and trying to show itself to you."

Berry continued: "If you take a picture, especially outside, sometimes the flash will reflect off dust or insects, and while they look round, they're not giving off their own light. Say that it's next to a tree and it's a real orb, the tree would be illuminated by this object. In Gettysburg, for example, I've seen orbs that give off their own light, and they are completely different than dust."

Since joining the *Ghost Hunters* team, Berry said he's been creeped out the most by the Graham Mansion investigation in Virginia, where the original owner was murdered by slaves and his body was mutilated and then turned into moonshine mash. "The stories we encounter when we do investigations really creep me out sometimes," he said, obviously shaken by the moonshine-mash concoction. "You have to get into their mindset, and it really can be intense."

However, he's less spooked when it comes to the supernatural and more wary of the living. "Places really don't freak me out," he joked, adding that he's had a few close encounters with wild animals while taping *Ghost Hunters*. "Sometimes the clients themselves are frightening…the things that they say or do can be totally crazy."

Scott Trainito and Mike Baker, Para–Boston and NECAPS

Who you gonna call? Scott Trainito, founder of Para-Boston, and Mike Baker, head of the group's scientific unit, called the New England Center for the Advancement of Paranormal Science (NECAPS), leave no gravestone unturned when they investigate a so-called haunted location in Boston. In fact, the duo's "real science, real answers" mantra cuts through the usual smoke and mirrors associated with Boston's "Boo!" business. With Trainito and Baker, there's no over-the-top *Ghostbusters* gear or fake Cockney accents. When it comes to scientific-based paranormal investigations, they're the real deal.

"Paranormal investigators and ghost hunters are two completely different things," said Trainito, who works as a postman in Everett when he's not spearheading Para-Boston investigations at night. "Paranormal investigators are looking for answers that are paranormal, which means they are unexplainable. Ghost hunters have already come to the conclusion in their minds that ghosts exist, and they try to capture evidence to substantiate those claims," adding that some of the scientific equipment used by ghost hunters on TV is just for show.

Mike Baker, head of Para-Boston's scientific unit called the New England Center for the Advancement of Paranormal Science (NECAPS), and Scott Trainito, founder of Para-Boston, have conducted hundreds of paranormal investigations throughout Massachusetts and take a scientific approach to the "Boo!" business. *Photo by Ryan Miner.*

"Basically, there is no ghost-catching device," explained Baker. "The field has changed. It has taken more of a fun-house approach—it has become a novelty—and it has set the paranormal investigation field back in a way. A lot of people are trying to use a screwdriver to hammer a nail. People go in with preconceived notions, and if anything happens, they're going to come to a certain conclusion. If something moves, bumps or they hear footsteps, they're going to automatically assume that it's a ghost, and that's a bad way to investigate. I have patents pending on three pieces of equipment, and it's more modifications to existing equipment to make it a little easier in the field."

Baker continued: "Technology can't detect spirits…we have to prove that spirits exist before we can build anything that can measure them. There was a shift in the field, occurring in the '90s, where it's a game to mimic what is seen on television. There was a period where it was purely scientific, and now people think they can turn off the lights, pick up an infrared camera and capture a ghost."

"It's because of the TV shows," added Trainito. "Look at TAPS on *Ghost Hunters*. They were actually a real group, and if you watch some of their earlier shows, they came into the investigations doing [it] exactly the way it's supposed to be done. The first few shows were much more interesting because you didn't know if they actually captured anything. Now, if you watch *Ghost Hunters*, every single show has evidence."

Baker said that it's highly unlikely to uncover paranormal activity during every investigation. "I've been on hundreds of investigations, and I'm lucky if 2 percent of the data collected could be considered paranormal," he continued. "There's a core group of people who still investigate the old-fashioned way, the scientific way, and don't take everything they see as a sign of ghosts. There are others who are like celebrity-hunting in Hollywood. They ride around, snap pictures and think they got one."

It's this drive to scientifically quantify every piece of evidence that separates Para-Boston from the rest of the paranormal-investigator pack. In fact, it's been Baker's lifelong passion to find the truth after having a close encounter with the supernatural at his childhood home in Arlington. According to the forty-year-old researcher, his mother saw an apparition, and he heard voices coming from his backyard. Several incidents when he was eight, involving inexplicable footsteps and slamming doors, have haunted him for years.

"There were all of these strange experiences where the bathroom door would slam shut and lock itself; it was a dead-bolt lock, and there's no way it could twist on its own," Baker explained. "Every week or so, we would

hear footsteps, and we could actually see the impressions of a foot on the hardwood floors. One night, my sister and I heard a loud bang coming from the kitchen, and it sounded like the silverware drawer was being opened and slammed repeatedly. We walked in cautiously, peeked in and it stopped. We opened the drawer, and all of the silverware was shoved at the end of the drawer as if it was slammed shut repeatedly."

Baker, who is more of the reserved Agent Scully type compared to his partner Trainito, said he still hasn't found what he's looking for when it comes to a science-based explanation. "I never got answers from my family as to why these things were happening, and we never talked about it until after we moved," he recalled. "I started reading books and never got the answers I was looking for. It wasn't just a childhood hallucination. There was something to it. I don't know what it is, and I still don't know what it is. I do know there is something, and I'm going to find it."

Trainito, the forty-four-year-old founder of Para-Boston, smiled when Baker shared his ghostly childhood experience, admiring his insatiable drive to find the truth. "That's the difference between a paranormal investigator and a ghost hunter," Trainito added.

Both getting their start in 2006, Trainito's paranormal investigation group has recently merged with Baker's NECAPS research unit. Baker's work, compared to Trainito's field research, focuses on points of geothermal and electromagnetic energy in New England overlaid with paranormal claims in an attempt to predict locations prime for activity. Patterns have emerged, including more supernatural incidents along fault lines, railroad tracks and areas where there are higher reports of UFO sightings. However, the NECAPS study found that the closer people are to a radio or television tower, the less likely there will be paranormal activity. "We left no stone unturned, even cemeteries." Baker said. "We found that there is no correlation to hauntings and cemeteries, which goes against what a lot of people believe."

The city with the most paranormal activity? "Weymouth, for some reason, is a hot spot," Trainito said, adding that Boston isn't far behind. "The evidence itself, ranging from apparition sightings to audio capture to smells, we never get those phenomena together. So if someone reports seeing an apparition and hearing footsteps, I'm wary because it's very rare to see an apparition and also hear audio," Trainito said with a laugh. "I mean, I've been investigating for years, and even I haven't seen an apparition."

INTRODUCTION

Wendy Reardon, Gypsy Rose Pole Dancing

When instructor Wendy Reardon worked her pole-dancing magic at her Boylston Street studio, Gypsy Rose, she conjured up a few paranormal pals and managed to capture the playful orbs on video. In fact, her mysterious tale of supernatural stripping went mainstream when the Biography Channel featured the noted author and former exotic dancer on the network's *My Ghost Story* in May 2011.

The weird thing about Reardon's segment? Not only does the forty-one-year-old see dead people, but she also pole dances for them. "I've got tons of clips with ghosties to show you," she said, opening her third-floor studio in Boston's Back Bay neighborhood and dimming the lights to set a spooky ambiance. "I've always loved dead things, but it scared the hell out of me when I first noticed these strange orb-like figures show up when I was taping myself dancing."

Reardon turned on her computer and played clip after clip of seven or eight eerie balls of light that hovered around her while she worked the pole. "I don't know what they are, but they've got some kind of intelligence because they'll swirl around, under, over and sometimes they'll even hover," she said, jokingly calling them "shpooks." Responding to critics who believed the orbs were reflections from her metallic dance poles or beams of light radiating from the mirrors in the studio, she said, "Trust me, they're not reflections."

The well-educated dance instructor, who made headlines in 2005 after writing a book called *The Deaths of the Popes*, generated a lot of buzz in the days leading up to the airing of the Biography Channel segment. In an interview with the *Boston Herald*, Reardon said she first encountered the phantoms at her studios in Quincy. She then asked them to follow her when she moved to the new space on Boylston Street in 2007. "I said, 'I want you guys to come with me,' and sure enough they did," she told the *Herald*. "I finally got a bunch of guys to like me and they're all dead!"

As far as differentiating the handful of spirits caught on camera, Reardon said she's given them playful nicknames. "There's seven or eight of them that have different shapes and different personalities," she said. "Bullet looks like a bullet. There's one that blinks as he goes along, so his name is Blinky. One I named Thriller because he's three-dimensional and made his first appearance when I danced to 'Thriller' by Michael Jackson."

Reardon reached out to several psychics to get the lowdown on the dancing balls of light but couldn't get a legitimate answer. In addition to the spirits featured in the *My Ghost Story* segment, Reardon said she's seen a new

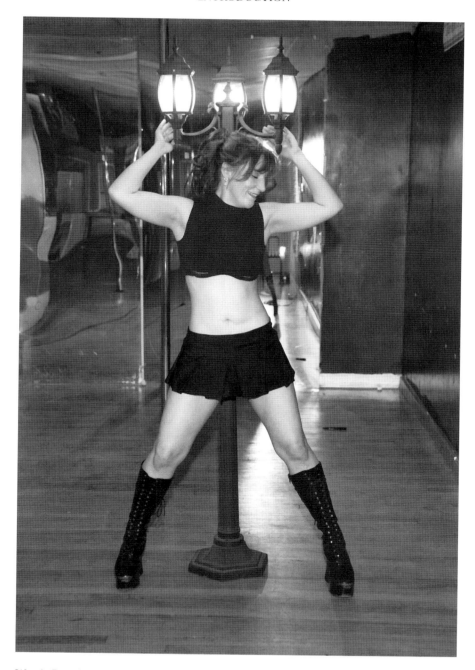

Wendy Reardon, who shared her story of supernatural stripping on the Biography Channel's *My Ghost Story* and claimed that her Boylston Street pole-dancing studio, Gypsy Rose, was haunted by multiple ghosts, channels her spirit squad. *Photo by Ryan Miner.*

pink-colored orb and a black shadow figure hover around her front desk. "I think it's the positive energy in the studio they're attracted to because really there's nothing special about me at all," she commented. "They fly around my clients too, and lots of clients have even captured them on their cellphones or video cameras. Who knows what they are…it's just really neat and humbling to have them in my studio."

The dance instructor, who has taught pole dancing for ten years, grew up in Hanover and majored in writing at Emerson College. After graduating in the early '90s, she moved to Los Angeles and freelanced for a slew of Hollywood animation studios. To supplement her income, she danced at stripper bars. She continued her exotic dancing in London, where she earned a master's degree at the University of Reading. "I put myself through graduate school by dancing," Reardon told the *Boston Globe* in 2005. "I never got into the lifestyle. It was just a job. But there's nothing wrong with it."

When asked if the ghosts following her around have had an impact on her personal life, Reardon laughed. "What dating life?" she shot back. "The only dates that I have are the dead guys who hang out here and the cops who come to the studio after hours."

In an attempt to get some historical back story on the spirits haunting her studio, Reardon visited the nearby location of one of Boston's most tragic disasters, the Cocoanut Grove nightclub fire that killed 492 people in November 1942. Because of its proximity to her studio, Reardon has parked at the site for years without realizing the correlation. "I was standing at the plaque where the revolving door was, and I held on to one of the iron fence posts, and again, it could just be my imagination, and I know I was holding onto an iron fence post, but it felt like I was gripping someone's hand…not physically, just emotionally," she recalled. "I felt like there were still souls trapped there."

Reardon shot video at the Cocoanut Grove site and found a black lacy glove that was probably dropped by one of the drag queens performing at Jacques Cabaret but oddly looked like an heirloom from the '40s. "In the sunken cement was a long black lacy glove…no lie," she said. "I actually got chills when I picked it up because it was so ironic." In the video, Reardon recorded a new orb to add to her collection of ghostly clips. "I just watched it now and there appears to be a 'sooty'-colored orb that flies up from the hole and along the glove," she explained. "I was going to take it with me but definitely got the feeling to leave it there. And there are little flakes of dust that fall off the glove, but the orb seems to come from the indented cement hole."

As far as her connection to the Cocoanut Grove site, Reardon said she had no idea it was so close to her studio even though she drove by it every day. "I want them to come finish their night with me at the studio, and maybe that's what some have been doing all along," she emoted. "I invited them, the spirits of the light, to finish their evening with me and to come with me to my studio where they can all dance, finish their drinks and just have fun."

JEFFREY DOUCETTE, HAUNTED BOSTON

Based on the freaked-out expression on Haunted Boston tour guide Jeffrey Doucette's face, he looked as if he had just seen a ghost. "You're not going to believe what just happened," he said, rushing into the Omni Parker House's mezzanine watering hole, Parker's Bar, one Sunday evening after giving a ghost tour to a group of high school kids from Vermont. "As I was telling a story at the site of the hanging elm, I could tell something was up," he recalled, packing up his lantern and sitting down at a cozy table near the bar's fireplace. "The chaperone is waving at me as if 'Jeff, you need to look at this,' and she shows me her camera. I literally couldn't believe what I was seeing. In the photo, it looks like seven nooses hanging from the trees in the area near what was the hanging tree."

Doucette, a four-year Haunted Boston veteran and a popular tour guide among out-of-town visitors thanks to his distinct South Boston accent, said he was a skeptic for years until he had a few close encounters of the paranormal kind while trudging through the tour's haunted sites scattered throughout the Boston Common and Beacon Hill. Now, he's a full-fledged believer. "I was like, 'What the…? Let's get out of here,'" he said, referring to the noose photo taken earlier in the evening and creepy pictures of demonic, red-colored orbs shot in the Central Burying Ground. "It literally freaked me out. This year, I've seen a lot of orbs, but nothing like what I just saw. I'm not sure if [the spirits] heard me talking about the interview I'm having with you, but they really showed their colors tonight. The ghosts in the Boston Common were out in full force, and they were screaming."

The thirty-six-year-old tour guide, who works in the finance department at a publishing house in Government Center when he's not moonlighting with Haunted Boston, said he was raised in a superstitious Irish Catholic

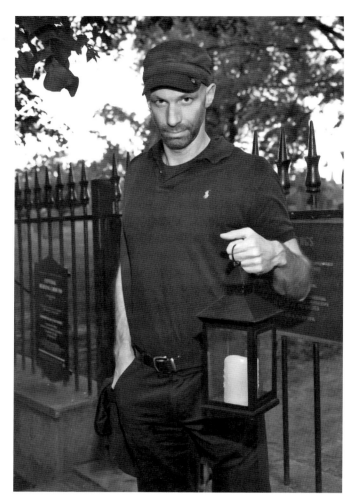

Jeffrey Doucette, a veteran ghost tour guide with Haunted Boston, had several close encounters with the ghosts from Boston's not-so-Puritanical past while leading groups to site-specific haunts scattered throughout the Boston Common and Beacon Hill. *Photo by Ryan Miner.*

family. "My grandmother was a tinker, or an Irish gypsy, and she would go to confession and then she would read Tarot cards to make sure she was covering both ends of the spectrum," he joked. "I suspect a little of that tinker mysticism was passed on to me. My mother would always say people would die in threes. When someone passed, we made sure we left the windows open to let the spirits out."

Doucette was an amused skeptic until he gave his first Boston Common tour in 2009. "A kid on the tour shot a photo of me, and there were all of these white orbs near the Great Elm site," he explained. "The last photo really threw me for a loop. It was of me with a green light coming out of my belly, and I was freaked out. Since then, we've had a few orbs here and

there, but this year has been out of control. Tonight, I really don't know what happened. Will I sleep? I don't know. But it was something that I've never experienced before."

The tour guide said he reached out to a psychic who told him that the green light emanating from his torso was an indication that the spirits in the Boston Common liked the way he told their stories. "At the hanging elm, many of the people who were hanged there [were done so] unjustifiably by the Puritans for crimes [they] didn't commit. If anyone disagreed with the status quo at that time, they were executed. Boston was founded by Puritans, and it was either their way or the highway…or the hangman's noose. Even in the modern age, if you disagree with authority, there's the chance that you can be shamed. In my opinion, many of those hanged in the Boston Common were victims of freedom of speech and died at the hands of oppressive authority figures. So when I say on the tour that many of the people hanged at the Great Elm site died innocently, I feel like I'm giving them a voice."

Doucette continued, "I've always been respectful of the spirits in the Boston Common. They've never bothered me at home, and I never had an issue with a haunting. But when I do the tours, they do come out. I've been a strong advocate for those who were disenfranchised and oppressed, especially women, and they always respond to the stories that I tell on the tour."

As far as historical figures, Doucette said he's drawn to people like Ann "Goody" Glover, who was hanged for allegedly practicing witchcraft on November 16, 1688. While Glover was exonerated of her crimes in 1988 and dubbed a "Catholic martyr" three hundred years after her execution, Doucette said he's compelled to tell her story. However, he's not convinced that Glover's spirit is haunting the Boston Common. "People want a big name to associate with the hauntings in the Common, but I seriously don't think that's the case," he said, adding that "it makes for good storytelling."

Doucette, who ends the Haunted Boston ghost tour at the historic Omni Parker House located at 60 School Street near Park Street station, said he's heard many creepy tales while downing a post-tour Scotch at Parker's Bar. "I spend a huge amount of time here," he remarked. "There was a night in October, and I came into the bar before a tour. A woman who was in her mid-fifties and working the bar asked if I gave the haunted tour and then told me the creepiest story." According to the Parker's Bar worker, one guest checked in but had a hard time checking out. There was an early-season

snowstorm, and the Parker House guest refused to pay his hotel bill. "As he was leaving and coming out of the School Street entrance, the doormat mysteriously flies up and blocks the exit as he's trying to leave," the tour guide mused. "The guy turns around and pays his bill."

Like Doucette, the man who tried to leave the Parker House without paying his bill was smacked in the face with what could have been a ghost from Boston's past. "Our history has many skeletons in its closet, and the spirits want their story to be told," he said. "I'm giving a voice to those without a voice."

CAMPUS HAUNTS

When it comes to school spirits, Boston has more than its fair share of them. Spine-chilling tales of unexplained sounds, flickering lights, residual apparitions and levitating objects have become a rite of passage for the uninitiated college-bound freshman adapting to life in one of the haunted dorms scattered throughout the Boston area.

Elizabeth Tucker, a professor of English at Binghamton University and author of *Haunted Halls: Ghostlore of American College Campuses*, said that collegiate ghost stories are morality plays for the modern era. "They educate freshmen about how to live well in college," she explained in a 2007 interview, adding that the cautionary tales serve as spooky metaphors of fear, disorder and insanity. They also reflect students' interest in their

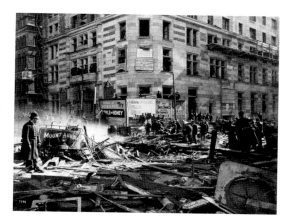

On March 4, 1897, a gas-line explosion at the corner of Tremont and Boylston Streets killed at least six people and injured sixty others. Some believe the psychic imprint left over from the disaster is tied to the spirits haunting Emerson College's dormitory The Little Building. *Courtesy of the Boston Public Library, Print Department.*

college's historical legacy. Yep, campus ghost lore is a paranormal pep rally of sorts. "You don't find ghost stories at schools without a sense of pride," Tucker continued. "School spirits reflect school spirit."

The difference between Boston's specters and other run-of-the-mill ghosts haunting universities throughout the country? Our spirits are wicked smart. Boston University's Shelton Hall, for example, boasts the ghost of a famed American playwright and Nobel laureate in literature, Eugene O'Neill. Harvard's Massachusetts Hall has one respectable-looking student who returns every fall claiming to be a member of the class of 1914. Apparently, the residual apparition of Holbrook Smith never got the memo that he was kicked out of the Ivy League almost a century ago.

We got spirits, yes we do.

CHARLESGATE

The Charlesgate Hotel, located at 4 Charlesgate East, is Boston's version of New York City's The Dakota building (which served as the creepy location for the film *Rosemary's Baby* and the spot where John Lennon was murdered). It has been a hotbed of alleged paranormal activity since it was built in 1891 as a fin de siècle hotel replete with glazed porcelain tiles and working elevators. Formerly a Boston University and Emerson College dorm, the ornately designed building is the source of a slew of student reports from the 1970s to the mid-'90s claiming the building was a supernatural vortex of evil.

In 1895, author Charles S. Darmell called Charlesgate "one of the most elegant family hotels in the city." The initial structure included thirty apartments and was constructed at a cost of $170,000, an enormous sum at the time. The building was sold in 1923 to Herbert G. Summers, who owned the hotel during the Depression era. Boston University purchased the building, housing four hundred female tenants, in 1947. In 1951, BU asked permission to remove the skylight and cover it with tar and gravel. By 1968, it housed almost five hundred students and had two dining halls. Apparently,

Opposite, bottom: When the notoriously haunted Charlesgate became an Emerson dorm in 1981, all hell broke lose. A bevy of myths—ranging from a "man in black" haunting the halls, unexplained noises and hidden rooms that were not included in the building's original J. Pickering Putnam blueprint to the ghost of a little girl, Elsa, who fell down the Charlesgate's elevator shaft—were reinforced by the structure's "haunted house" aesthetic. *Photo by Ryan Miner.*

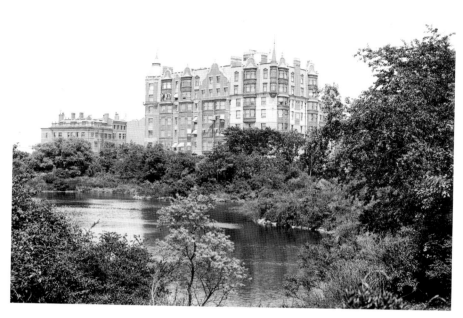

The former Charlesgate Hotel, located at 4 Charlesgate East and a former Boston University and Emerson College dormitory, has been a hotbed of alleged paranormal activity since it was built in 1891. *Courtesy of the Library of Congress.*

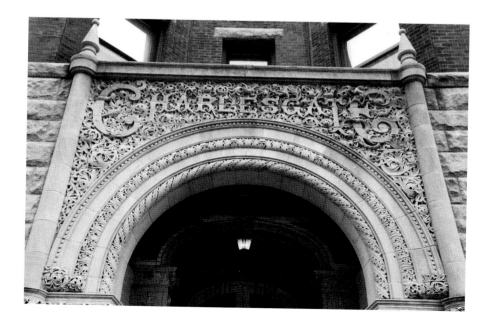

students enjoyed living in a textbook example of a haunted house. In fact, the *Charlesgate Hall Handbook* from 1956–57 described the building as BU's very own "witches castle," alluding to its Gothic-style architecture that was once suitable for Boston's Brahmin elite.

There were several elevator-related accidents at the Charlesgate, including a broken hoist cable that rattled four ladies in the '40s. The more severe incident, happening in 1947, involved a female student walking into the elevator shaft and plunging six floors. Apparently, she didn't die from the fall, nor was it confirmed as a suicide attempt. However, the myth surrounding that fateful nose dive has perpetuated an onslaught of paranormal legends that continue today.

Rumors began in the '70s, when Boston University students claimed that they were feeling bad vibes from a sixth-floor closet after discovering an alleged suicide had taken place there years prior. For the record, the suicide stories were never confirmed. "Went to Emerson for grad school from '87 to '89. My friends lived on the sixth and the top floors. This was nicknamed the 'suicide dorm' when it was part of Boston University's campus," recalled Mark from Arizona. "I always felt creeped out in that place, and though we weren't allowed, we did play with a Ouija board."

Here's where Mark's tale gets strange: "It led us to find a door hidden in a closet that led to a small hidden space between walls. An old fireplace was in it and a shoe from what looked like the middle of the twentieth century. After that, one of our friends who was involved became very sick and started acting strangely. Pretty creepy."

When the notoriously haunted site became an Emerson dorm in 1981, all hell broke lose. A bevy of myths—including a "man in black" haunting the halls, unexplained noises, hidden rooms that were not included in the building's original J. Pickering Putnam blueprint and the ghost of a little girl, Elsa, who fell down the Charlesgate's elevator shaft—were reinforced by the something-wicked-this-way-comes vibe that emanates from the fourteen-thousand-square-foot space with turreted bay windows looking out over the Charles River. There were even rumors of Mafia hit men knocking off victims in a soundproof room on the seventh floor and Satanic cults performing sacrifices.

In 1981, Emerson's newspaper, the *Berkeley Beacon*, reported that a spitfire of an evil creature called a "Fury" set up shop in the Charlesgate basement, while others mentioned that paint from a door had been scratched off to look like the devil himself. However, the harmless spooks from the early '80s took a much darker turn as the decade progressed.

In October 1988, the *Boston Phoenix* put out a tongue-in-cheek Halloween story called "Boston's Trail of Terror!" portraying the Charlesgate as a "devilish dormitory" where two-thirds of the building was inhabited by members of a Depression-era demonic cult. Journalist David W. Bromley contended that at least two grisly murders happened there, including those of a young boy in the downstairs stables and one on the top floor. The article continued, saying that the dorm was a "snake pit of spirits" by the '80s, that Emerson students would brush off close encounters with devil-worshiping fellow tenants and that it was commonplace to see a black pentagram painted on the floor surrounded by burning candles. According to the report, temperatures would drop and blankets were ripped off students during the wee hours of the night.

Jamie Kagliery, an Emerson student in 1986, wrote a term paper talking about Charlesgate's eerie temperature fluctuations even though the windows were shut. The young writer also told the story of "a man dressed completely in black," a so-called spirit who would stalk the seventh floor. He also claimed that room 611 was home to a series of suicides and that alarm clocks on the floor would sporadically go off at 6:11 a.m. without fail.

One anonymous source from Colorado, a former Charlesgate tenant who lived on the third floor, alluded to Kagliery's "man in black" story years later in an interview with me for this book. "I experienced many creepy feelings, but what really disturbed me was the night when I was alone in my room… and someone in a dark cloak crossed my room and the door behind my head did not open," she recalled. "I turned around, and no one was there. I had heard it was the spirit of a man whose child had died in the stairwell and he killed himself in remorse. It was rumored that he watched over the girls to protect us. I hid under my covers for some time, but I did sleep that night, so maybe he was a positive spirit. The medium boards were frequently used, and there were some not-so-good energies which made us stop many times. I heard many rumors."

A handwritten note kept in the "Charlesgate Hauntings" file at the Emerson Archives recounted an alleged encounter dating back to 1987. In the story, Cindy Ludlow felt "the top bunk move" in room 327, even though no one else was there. Allegedly, the bed's sheets were pulled back. Based on the note, Ludlow apparently reached out to a friend with psychic abilities who said that it was the spirit of a little boy who "just wanted to play."

In the February 1990 edition of *FATE* magazine, former Emerson student Tracey Libby penned an elaborate Ouija-board tale that perpetuated the Satanic cult myth, saying that "it was not unusual for a student to walk by

the open door of a room belonging to a cult member and find a group of them chanting." In her "Closing a Window in Charlesgate Hall" story, Libby paid homage to the building's arrested decay, pointing out that the antique bathroom had tubs that sit on legs with clawed feet. She also recounted a Ouija party where five freaked-out freshmen contacted an evil spirit called "Mama" and a helper guide named "Pete."

During the spirit session, they got a call from a parent who was supposedly psychic and "had seen a red flag signaling danger." According to the concerned father, Libby had "opened a psychic window, letting evil spirits through." The party of five tried to help a lost soul and was told to go to the boarded-up elevator at midnight. Libby talked about the "shaft girl" story, alluding to the elevator accident in '47 and a bloody crime scene behind the closed elevator. She also referred to the "man in black" myth. For the record, he had an injured arm in her yarn and "supposedly roamed the stairwell that surrounds the old elevator." Libby's published tale has a disclaimer saying that all names were changed for privacy but the story, "amazing as it sounds," is allegedly true.

There are several Ouija-board stories circulating from the late '80s. According to lore, the spirit games were banned from the dorm "because of their psychological effects on students due to evil messages," wrote Libby. While students who lived in Charlesgate Hall during that era insist that the boards weren't allowed, there are no references to the so-called Ouija board rule in Emerson's housing and resident life handbooks in the early '90s. Pot-smoking college kids playing with a Ouija board? Now that's scary.

Also, the "shaft girl" story about Putnam's daughter Elsa who supposedly fell down the elevator shaft and died while chasing a ball isn't true. In fact, Elsa Putnam had four children and lived in Boston until her death in 1979. Ironically, the story of Elsa's ghost, who was rumored to wander the halls of Charlesgate looking for her ball and a new playmate, transferred over to Emerson's other haunted dorm, The Little Building, when the college purchased it in 1994.

Robert Fleming, former archivist and current executive director of the Emerson College Library, gave a spirited speech in 1992 on the history of the grand hotel. "On haunting, I'm not going to say unequivocally that there are not ghosts," he remarked. "In fact, if there are any spirits of the dead that you should steer clear of in this building, it is probably the ghost of John Pickering Putnam, who probably puts a curse on anyone who does any damage or shows any disrespect to his beloved Charlesgate Hotel."

Three years after Fleming's speech, Emerson sold the creaky Hogwarts-esque structure located at 4 Charlesgate East. Now that the building is an

Emerson College sold the creaky Hogwarts-esque structure located at 4 Charlesgate East, and the former "devilish dormitory" has been turned into an upscale condo complex. The Charlesgate's ghost-story frenzy of the '80s and '90s seems like a forgotten tale from the crypt. *Photo by Ryan Miner.*

upscale condo complex, the ghost-story frenzy of the '80s and '90s seems like a forgotten tale from the crypt. Perhaps Fleming's words about Putnam's ghost were true: Once the building ended its half-century term as a college dorm and returned to its original glory as an apartment complex for Boston's upper crust, maybe Putnam's spirit was finally laid to rest.

File under: hex education

BERKLEE COLLEGE OF MUSIC'S 150 MASSACHUSETTS AVENUE

Many talented musicians have passed through the halls of Boston's Berklee College of Music since it was founded in 1945. The rock 'n' roll school has attracted a slew of singer-songwriters like John Mayer, Natalie Maines from the Dixie Chicks and drummer Joey Kramer from Aerosmith. Those on its growing list of alumni continue to be the who's who of Boston's local music scene.

Like its collegiate neighbors, Berklee has a haunted dormitory, located at 150 Massachusetts Avenue. The site, formerly the Sherry Biltmore Hotel, was damaged in a massive fire during the early morning of March 29, 1963, killing four guests and injuring twenty-seven. The source of the blaze was an eight-year-old boy who was staying on the sixth floor. He later told investigators that he was playing with matches in an unoccupied suite, room 655.

Of course, the ghost lore surrounding the building has taken on a life of its own. Former Berklee students have shared stories of inexplicable gusts of air, levitating objects and all sorts of unidentifiable sounds. "People see weird shadows and hear bizarre noises at night," confirmed Colt Wolff in an October 2011 interview with the *Boston Globe*, adding that a creepy picture of what looked like an apparition was shot in one of the dorm's rooms and circulated among students. "You're like, 'Well, it's an old building, so there's no way to know.'"

The stories, dating back to its purchase in 1972, have been consistent over the years, and students strongly believe that the ghosts roaming the halls are victims of the fatal hotel fire. The building was built in the early 1900s as an apartment complex and was reopened in 1955 as the Sherry Biltmore. The hotel was almost fully occupied at the time of the blaze, according to a report in *Boston's Fire Trail*, and a late-night party was going on in suites 601 through 611 for a departing cast member of the touring musical *The Sound of Music*.

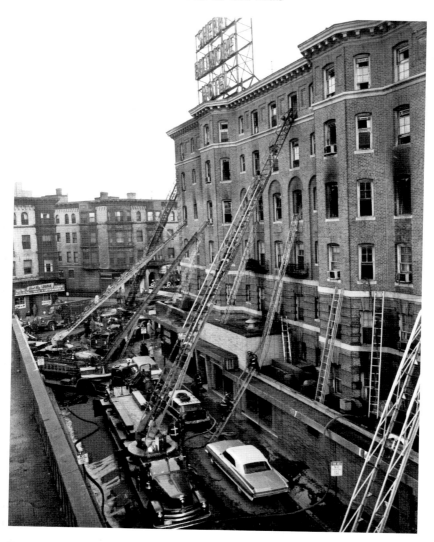

Berklee College of Music's haunted 150 Massachusetts Avenue dormitory was formerly the Sherry Biltmore Hotel, which was damaged in a massive fire during the early morning of March 29, 1963, killing four guests and injuring twenty-seven. *Courtesy of William Noonan, Boston Fire Historical Society, www.bostonfirehistory.org.*

The rescue is legendary among Boston Fire Department historians, who call it "one of the most spectacular jobs of raising ladders." Ten ladder companies responded to the disaster, rescuing approximately one hundred people, many over ladders, while the entire sixth floor was engulfed in flames. Guests trying to escape out of windows were blocked by air-conditioning

units. One man tied his bedsheets together and fell twelve feet, uninjured, while two boys slid down a pole to safety.

Berklee students believe that the residual trauma of that fateful morning continues to wreak havoc in the dorm, even after the college renovated the building in 1999. "The strange thing I can remember is my roommate and I sitting doing homework and the TV flying across the room…the windows were closed," recalled one anonymous student who lived in the dorm in 1985. "Oftentimes at night and sometimes in the afternoon, there would be knocking on the door…frantic knocking. We'd open it while the knocking was happening, and there wouldn't be anyone there."

Richard G. said that he was initially skeptical about the ghost stories until he had a late-night encounter back in 1993. He was lying in bed and noticed a hairbrush fly off his dresser. "I assumed my roommate may have thrown it at first, but I looked and he was asleep," he told me. "Then, I thought to myself that this was just like a similar experience I heard about. It felt benign and not malevolent." He heard other Berklee students talk about "objects moving and falling. Also, hearing voices in the steam pipes. But the steam pipes were really noisy."

The boy who admitted to starting the fire was the son of one of the cast members of *The Sound of Music*. Partygoers recalled the sheer panic of trying to get out of the sixth-floor inferno, smashing windows and crawling out of a small bathroom window, head first, and finding refuge on a nearby roof. The Austrian-born child, whose mother played a nun in the Rodgers-Hammerstein musical, told police that he liked to hear the "fizz sound" of matches when asked why he sparked the fatal fire. However, Berklee College of Music students find no solace in the eerie sounds of terror emanating from the dormitory halls of 150 Massachusetts Avenue.

File under: haunting harmony

Boston University's Shelton Hall

Up-and-coming writers at Boston University flock to Shelton Hall's fourth floor, known as the dorm's Writers' Corridor, to hobnob with the spirit of lauded, and notably tortured, playwright Eugene O'Neill. The *Long Day's Journey Into Night* author—crippled with a slew of ailments ranging from a rare genetic neurological disease to tuberculosis to depression to stomach disorders exacerbated by alcoholism—spent the last two years of his life

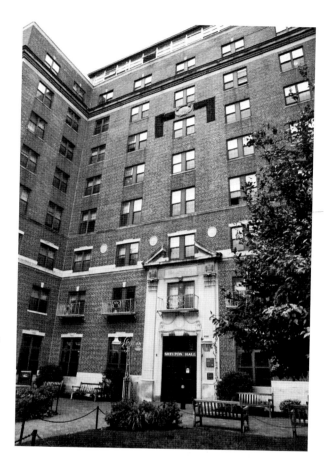

Boston University's Shelton Hall, 91 Bay State Road, is believed to be haunted by one of America's greatest playwrights, Eugene O'Neill, who spent the final years of his life in what used be the Sheraton Hotel. *Photo by Ryan Miner.*

in suite 401 when the BU dormitory located at 91 Bay State Road was a Sheraton-owned hotel. Shelton was originally built in 1923. Ironically, O'Neill was born in a hotel, the Barrett, located at 1500 Broadway in the heart of New York City's Times Square.

Son of Irish immigrant actor James O'Neill and Mary Ellen Quinlan, *The Iceman Cometh* author suffered severe Parkinson's-like tremors caused by the late onset of a genetic neurological disease called cerebellar cortical atrophy, which he suffered from in his fifties until his death at age sixty-five. As O'Neill's health deteriorated, he insisted that he "wanted no priest or minister, or Salvation Army captain at his deathbed." He continued, "I will face God, if there is a God, face to face, man to man." The uncontrollable shaking impaired his ability to write, and he struggled with tremors later in life, allegedly asking his wife, Carlotta, to

destroy many of his uncompleted plays. For the record, Carlotta initially claimed that she and her husband burned the unfinished manuscripts in a Shelton Hotel fireplace. There are no fireplaces in the building. After questioning from reporters, Carlotta later recanted the story, saying that she destroyed the unfinished plays, shredding the pages and then handing them to a janitor who burned the shreds in an incinerator located in the building's basement.

O'Neill spent his last days downing shots of whiskey in suite 401 to numb both the emotional and physical pain. He forced the liquor down his throat and, in essence, drank himself to death. His famous last words? "Born in a hotel room and goddammit, died in a hotel room," he reportedly whispered to Carlotta three days before his final curtain call on November 27, 1953. The playwright is buried in a modest grave at Forest Hills Cemetery in Jamaica Plain. However, his spirit apparently lives on.

O'Neill's wife, who moved to Shelton in 1951 because of its proximity to her shrink's office on Bay State Road, insisted that her husband's ghost was in the room and that he talked to her into the wee hours of the night. These so-called phantom conversations may have inspired Carlotta to release O'Neill's autobiographical masterpiece, *Long Day's Journey Into Night*, in 1956 even though he had clearly stipulated that he didn't want to make it public until twenty-five years after his death. Perhaps O'Neill's postmortem spirit had a change of heart. He posthumously won the Pulitzer Prize in 1957.

Boston University purchased the Bay State Road building in 1954, and Carlotta soon checked out. However, her famous husband's tortured soul is rumored to remain in Shelton Hall. Reports of an elevator mysteriously stopping on the fourth floor, phantom knocks, unexplained gusts of wind and inexplicably dim lights continue to creep out students who live in the dorm.

"Strange things do happen," said former Shelton Hall resident Stephanie Lui to *BU Today* in 2009. "For example, there was a period of time at night when a gust of wind would blow underneath the door from the hallway into our room. It made a loud noise, and we couldn't figure out why wind would be blowing within the building."

David Zamojski, assistant dean of students and director of residence life at BU, insisted that some still believe the urban legend. "Students have been telling stories about O'Neill's spirit and ghost as long as I've been here," he said. "We have received reports of many a strange incident."

Zamojski, in an interview with the *Daily Free Press*, mentioned the flickering lights and phantom knocks. "I remember hearing stories from students that

they would hear sounds, like doors closing or knocks at the door. When they opened their own doors, there would be no one out in the corridor," he said. "I even remember a student saying that he or she had seen sort of a shadowy figure in the corridor."

File under: phantom playwright

BOSTON COLLEGE'S O'CONNELL HOUSE

When revered ghost hunter Lorraine Warren—known for her work with the Amityville Horror case and co-founder with her husband, Ed, of the New England Society for Psychic Research—visited Boston College's O'Connell House back in 2001, students finally got a confirmation of sorts that the thirty-two-thousand-square-foot building dating back to 1895 was indeed haunted. However, one of the three spirits causing a stir in the attic had more bark than bite. Yep, one of O'Connell House's resident ghosts is a friendly pup and not some ferocious devil dog guarding the gates of hell. C'mon, Boston College is a Jesuit Catholic university, for goodness sake.

Warren, who helped exorcise a "werewolf demon" in 1983, conducted an impromptu search of the Upper Campus student union, according to the October 21, 2001 edition of *The Heights*. For the record, Warren also coauthored the book *Werewolf: A True Story of Demonic Possession*, which chronicled the bizarre case of Bill Ramsey, who literally bit people during the alleged possession. "She said that there were two ghosts in the attic that either hanged themselves or jumped, and there was also a dog spirit that she said was following her around the house," confirmed house manager Zach Barber. "She also said, 'You must hear furniture moving around up there [in the attic] all the time.'" Warren's psychic hunch was later confirmed by staff members; they did indeed hear unexplained noises coming from the O'Connell House attic.

"She said she could really sense something here," Barber recalled in a later interview. "[Warren] said it was a lot of positive energy."

Originally built by the Storey family in the late 1800s, the building was the home of drugstore czar Louis K. Liggett, who lived there until 1937. After Liggett, the building had a short stint as a Jesuit retreat until Boston Archbishop Cardinal William O'Connell donated it to BC in 1947. Before it became a student activity center and residence hall in 1972, the building

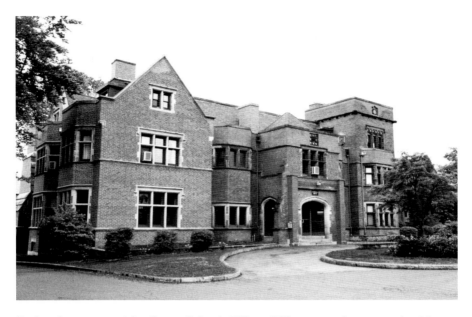

Students have suspected that Boston College's O'Connell House sported paranormal activity, with lights inexplicably flickering on and off, blinds closing by themselves and electronic appliances like hair dryers turning on in the middle of the night. *Photo by Ryan Miner.*

housed the college's football team and management school. Known for its Tudor architecture and sprawling garden area, O'Connell House served as a location in the 1947 black-and-white Nazi spy flick *13 Rue Madeleine*, starring James Cagney.

Over the years, students suspected that O'Connell House had paranormal activity, with lights inexplicably flickering on and off, blinds closing by themselves and electronic appliances like hair dryers turning on in the middle of the night. However, there was no tangible proof from the two-legged specters. The dog spirit, in contrast, has made his presence known to former students like Feven Teklu. "Every now and then I'll be lying in bed and see this little dog sitting under my desk looking at me," mused Teklu in an October 2002 interview with the *Boston College Chronicle*. "It's there and then it disappears. It's kind of eerie and definitely a mystery." The odd thing? Neither Teklu nor her housemates ever owned a dog.

Back in 2009, ghost hunter Jeff Davis conducted a paranormal research session at the turn-of-the-century student union armed with an audio EVP (electronic voice phenomenon) recorder in an attempt to find scientific proof. One of the investigators on Davis's team asked, "Is this your favorite room

in the house?" According to an account by the *BC Observer*, a ghostly voice could be heard on the digital recorder saying "No, no!" Davis had captured a so-called EVP. However, he didn't hear a growl from the hall's four-legged spirit. Apparently, the phantom pup doesn't like strangers.

File under: ghostly growl

EMERSON COLLEGE'S THE LITTLE BUILDING

Students at Emerson College, a top-notch communications school located in the heart of Boston's haunted corridor, insist that The Little Building, a twelve-story residence hall at 80 Boylston Street, is a hotbed of paranormal activity. The resident specter is a little girl who, looking for her ball, allegedly plunged to her death in the building's freight elevator during construction in 1917. According to ghost lore, the child was the daughter of a construction worker, and her residual apparition is allegedly on the prowl for the lost toy. Apparently, she's never found her ball.

Known as the "freight girl" or "shaft girl" ghost, her legend is a rite of passage for impressionable freshmen moving into The Little Building. Lena

Emerson College's The Little Building, 80 Boylston Street, is rumored to be a hotbed of paranormal activity and is home to the "freight girl" or "shaft girl" legend, coupled with reports of a "devilish dentist" spirit roaming the halls. *Courtesy of the Boston Public Library, Print Department.*

Grosse, a former Emerson student who heard of the little girl spirit while taking the elevator to her freshman speech class, told the *Berkeley Beacon* in 2009 that she didn't take the dorm myth seriously. "I knock on wood. I'm superstitious, I guess," she said. "And I'm sure someone did fall down the elevator. I'm just not sure if I believe in ghosts."

Oddly, an April 29, 1929 report from the City of Boston's building department alludes to an elevator malfunction, saying that the "gate on the freight elevator has been repaired." According to the memo addressed to commissioner L.K. Rourke, all of the eight passenger elevators were in fine working condition, and the mysterious freight's lift was back up to code. No mention of a heinous tragedy involving a broken gate.

Christina Zamon, head of Emerson College's archives and special collections, said the ghost story "is a transfer from Charlesgate," alluding to the story of Elsa, the seven-year-old daughter of architect J. Pickering Putnam whose spirit was rumored to wander the halls of Charlesgate looking for her ball and a new playmate. "If you're familiar with both stories, the file on Charlesgate will show you that they're basically the same story." Zamon is correct. In fact, Elsa Putnam didn't fall down an elevator shaft. She had four children and lived in Boston until her death in 1979. The two stories are almost identical.

While the shaft girl myth seems to be an urban legend, there is a macabre disaster of historical merit associated with The Little Building site. Long before Emerson purchased the building in 1994 and even before noted architect Clarence Blacknell drew up plans for the structure in the 1910s, there was the Hotel Pelham. It wasn't actually a hotel but one of the first apartment buildings in America dating back to 1857 and billed as "a city under one roof." The Pelham was leveled in 1916 to clear space for The Little Building. On March 4, 1897, a gas-line explosion at the corner of Tremont and Boylston Streets killed at least six people and injured sixty others. The leak was from a six-inch gas line located beneath the street and above the Tremont subway tracks. A spark from a trolley car caused the gas to ignite. The explosion caused thousands of windows to shatter, including panes at the Hotel Pelham facing the Boston Common. Weeks before the disaster, a major gas leak was reported at the apartment complex, and service was shut off.

Some believe the residual energy left over from the 1897 gas-line explosion is tied to the haunts spooking students at the 80 Boylston Street dorm. One story involves a malevolent specter who allegedly scratches students in their sleep. "I heard about this girl who was in the shower and noticed really weird scratches

on her back," said Nick Coit, a former Little Building resident assistant, in 2009. "Her friend [on the tenth floor] woke up with the same thing."

Emerson students have developed their own myth behind the mysterious scratches, claiming that a "demonic dentist" apparition is roaming the halls. "The dentist appears to RAs specifically," Andrew Schlebecker told the *Berkeley Beacon* in 2011. "They will wake up in the middle of the night to see a figure with a tray full of [dental] tools in front of them." Apparently, it's a custom for resident assistants to unplug everything the night before they pack up and leave the building. Some claimed that their lights had mysteriously been turned on while they were asleep, while others woke up with inexplicable scratches on their arms.

For the record, the 1897 gas-line explosion was so intense that a dentist in the southwest corner of the Hotel Pelham was physically blown away from his patient, mid-surgery, and thrown across the room. The doctor wasn't listed among the casualties. However, it's rumored that his spirit has returned to the scene of the disaster to finish off what he started.

File under: dental hijinks

HARVARD UNIVERSITY'S MASSACHUSETTS HALL

One restless spirit has taken the whole "pahk the cah in Hahvad Yahd" idiom quite literally…for almost a century. Harvard University's Massachusetts Hall has been the Ivy League's crown jewel, touted as the oldest building on the Cambridge campus and boasting a historical lineage that dates back to the country's second president, John Adams. For the record, he shared a triple room on the first floor in the 1750s. Its solid brick façade has been a symbol of American intelligentsia and has been the Yard's tacit sentinel for almost three centuries, dating back to 1720.

The Early Georgian–style dorm and office building, which currently houses freshmen on the top floor and served as a temporary barracks to 640 Continental soldiers during the siege of Boston during the Revolutionary War, is also notoriously haunted. "Eighteenth-century buildings should have ghosts," mused William C. "Burriss" Young, who lived in Mass Hall for decades as an assistant dean of freshmen. "If there are going to be ghosts, it makes sense they should live in the nicest building in the Yard."

According to campus lore, the resident ghost known as Holbrook Smith was a "tall, respectable-looking older gentleman" who would chat up

Harvard University's Massachusetts Hall had a resident ghost called Holbrook Smith, who was a "tall, respectable-looking older gentleman" known to chat up freshmen and claimed to be among the class of 1914. *Photo by Ryan Miner.*

freshmen and claimed to be among the class of 1914. He would return to the dorm every fall for almost a century until Young confronted the so-called phantom and asked him to leave. He looked at the dean of freshmen, with "the saddest eyes I've ever seen," recalled Young in an interview with *Harvard Magazine*, and said, "You've ruined a perfectly good thing." Smith's spirit hasn't been seen roaming Mass Hall since that mythic confrontation.

Students and faculty have talked about the Mass Hall haunts for years. Thomas E. Crooks, a former administrator who passed away in 1998, told the *Harvard Crimson* in '89 that "in Massachusetts Hall, there are a couple of ghosts who are passing as people." Crooks said that he had close encounters with spirits roaming the halls of Harvard. "Every time I see one, I forget it right away," Crooks said. "It's such a traumatic experience that I erase it from my mind at once."

Historically, Harvard students have had a whimsical fascination with the spirit realm. In 1948, a group of eight men and three Radcliffe students formed an on-campus "spooks club." The group investigated a haunted mansion in Boston's Back Bay. Apparently, a high school teacher moved into the boarded-up estate in 1947 and had a run-in with an apparition. "They centered around the stairs," she told one of the club members. "Twice I

saw a figure hovering there, and I was afraid to go upstairs." According to the report, the third time the phantom appeared, the woman asked "Who's there?" and it disappeared.

Other halls, like Weld and Thayer, are also reportedly haunted. One student swore she saw "an old woman with a dark cloak and grayish hair" in Weld North in 1985. "It wasn't like the mist that you see in the movies," she recalled, "but it was very vague—like an impression. I couldn't see any of her features. She was just leaning against the wall, listening to our conversation." Weld legend suggests that "when Weld was rebuilt after burning down in the 1960s, a spirit was bricked in between the walls," said the dorm's proctor. "Students often hear mysterious knocking on the walls."

Thayer Hall made Hollow Hills' "Haunted New England Colleges" list in 2009. According to the website, spirits wearing Victorian-era clothing were spotted entering and leaving the building through doors that no longer exist. "A professor who chose to remain anonymous contacted me and said that he had seen Victorian figures going through areas in the hall where there used to be doors and there aren't now," said Fiona F. Broome, who came up with the most-haunted list. Broome told the *Crimson* that her source "was not a crazy person" and that "he had a lot of credibility. Just in the way that he wrote."

However, the hype surrounding Holbrook Smith continues to trump Harvard's other alleged campus hauntings. In the late '70s, a noted clairvoyant visited the Massachusetts Hall dorm to investigate if residual spirits were indeed haunting Harvard's oldest building. "The speaker warned students that any photographs taken of her would not come out because of the strong supernatural presence in the room," reported the *Crimson*. "Sure enough, the photographs came out blank."

File under: freshman fear

COMMON HAUNTS

There are many secrets buried beneath the hallowed grounds of the Boston Common. From its beginnings as a sheep and cow pasture in 1634, just a few years after the city itself was founded, the forty-eight-acre green space purchased from Boston's first settler, William Blackstone, has since been touted as the oldest city park in the United States. It's also home to some of the darker chapters from Boston's not-so-Puritanical past.

Yep, the Boston Common is chock-full of ghosts, graves and gallows. It is, in essence, "one big anonymous burying ground," wrote Holly Nadler, author of *Ghosts of Boston Town*. "Under the Puritan regime, untold numbers of miscreants—murderers, thieves, pirates, Indians, deserters, Quakers and putative witches—were executed in the Common" at the so-called Great Elm, which was also nicknamed by locals as the hanging or gallows tree. "At risk to their own lives, friends and family might sneak in under the cover of darkness, cut down the cadaver and bury it somewhere in the park," continued Nadler. "If no one came forward to deal with the disastrous remains, town officials disposed of them in the river, where bloated bodies frequently washed in and out with the tides."

There was also a mass grave site near the southern corner of the Common, yards away from the designated Central Burying Ground. In early 1895, the human remains of one hundred dead bodies were uncovered during the excavation of the nation's first underground trolley station, now the Boylston Green Line stop. A mob scene of "curiosity seekers" lined up along the Boylston Street corner of the Common "looking at the upturning of the soil," according to the April 18, 1895 edition of the *Boston Daily Globe*. The

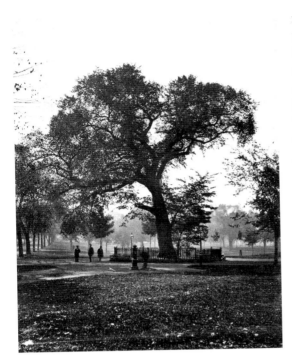

The historic Great Elm, which fell during a violent windstorm that swept through the city on February 15, 1876, was also known as the hanging tree, where Boston's alleged witches, rakes and rogues met their untimely death. *Courtesy of the Boston Public Library, Print Department.*

report continued, saying that "a large number of human bones and skulls are being unearthed as the digging on the Boylston Street mall" progressed. Thrill-seeking spectators were horrified by the sights and smells emanating from the site and were forced to move by early May.

And that was just the first round of skeletons in the Common's collective closet. As the excavation continued, officials uncovered the remains of hundreds—some historians estimated between 900 and 1,100 bodies—buried in shallow graves beneath the Boylston mall.

In addition to its skeletal secrets, Nadler also pointed out the Common's odd lack of flowers compared to other parks in Boston, like the neighboring Public Garden. Her theory: "Nothing festive can thrive for long in this energy vortex of unjust killings and unmarked graves." She's right. There aren't any blossoms in the otherwise picturesque mass grave site—not even a rose or two for the restless spirits rumored to haunt the park at night.

Flowers for the dead? Not in the Boston Common.

BOYLSTON STATION

If Boston had a ghost station, it would easily be the Green Line's Boylston. The oldest rapid transport platform in the United States, the station dates back to 1895, when the morbid groundbreaking work began.

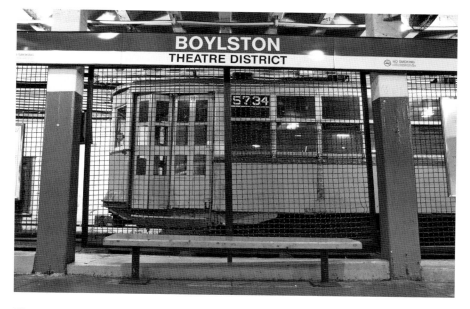

There are reports of a British soldier apparition in full redcoat regalia standing in the middle of the tracks at the Boylston T station, the oldest rapid transport platform in the United States, dating back to 1895. *Photo by Ryan Miner.*

It was opened officially two years later in 1897. Compared to Boston's neighboring underground T stops, the station has retained much of the original turn-of-the-century charm, including the occasional display of an old-school PCC (Presidents' Conference Committee) trolley designed in the 1930s and used during World War II. The bright orange streetcar, a remnant of a bygone chapter from Boston's transit history, is prominently displayed on a side track near Boylston's inbound platform. There's also an abandoned underground passageway connecting Emerson's haunted dorm, The Little Building, to the northbound platform. The tunnel is now blocked by an electrical substation.

Like its Emerson College neighbor, the Boylston T station is notoriously haunted. In addition to its series of abandoned ghost tunnels, which have linked the present-day station to the South End since 1962, there are reports of "a British soldier, in full redcoat regalia, standing in the middle of the tracks holding a musket," according to the ghost tour guides at Haunted Boston. The Revolutionary War redcoat is a so-called residual haunting, a playback or recording of a traumatic past event. Trolley conductors usually see this gun-toting apparition during the early morning shift or the wee hours of the night. The ghostly trek from Arlington to Boylston is rumored to be a

hazing ritual of sorts for new T recruits. They slam on their brakes, obviously freaked out by the human-shaped mist, while the more experienced drivers get a kick out of spooking the newcomers.

Why would a Revolution-era casualty of war haunt Boylston station? During the gruesome excavation project in 1895, historian Samuel A. Green was called in to identify the skeletal remains of what turned out to be a mass grave site. "It is impossible to tell who is buried there, but we know that the British during their eight months' occupancy of Boston in the revolutionary struggle, buried some of their soldiers who were killed at Bunker Hill there," he told the *Boston Daily Globe* in April 1895. "Others who died from the effects of wounds in this battle were also interred there."

The *Globe* reported that on the days the excavation took place, hordes of curious onlookers gathered around the dig site, prompting police to set up a barricade. A canvas had to be "spread over a couple of pieces of joint to shut off the view of the spectators in the vicinity of the tombs." One mysterious man walked into the transit commission office requesting permission to take bones retrieved from the site. He had no intention to keep the remains, he said, but "wanted a few bones to measure." Dr. Addison Crabtree ended up breaking through the barrier and doing the renegade research. "I would have preferred to have made my measurements and drawings at my office, but that I couldn't do, so I took my tape, rule, pencil and paper, and went up to the subway and made them there," Crabtree said.

Articles of hair and clothing were oddly well preserved within the subterranean pool of bodies, even though the battle occurred more than one hundred years before the dig. Some say many of the British soldiers were missing limbs and other body parts because of shoddy, pre-sterilization medical care. There's a generic gravestone at the Central Burying Ground honoring the desecrated 900 to 1,100 bodies uncovered during the trolley station excavation. The marker reads: "Here were re-interred the remains of persons found under the Boylston Street mall during the digging of the subway 1895."

Based on ghost lore, hauntings have been associated with the lack of proper burial or a later desecration of the grave. Countless spirits, according to paranormal researchers, have been traced to missing gravestones or vandalism of a resting place. Perhaps the restless British soldier apparition has his musket drawn in a postmortem attempt to be more than an unnamed bag of bones. It's plausible that he's seeking answers from the Patriot ancestors who unknowingly rode the underground trolley through what was, in essence, a dead man dumping ground.

File under: residual redcoat

CENTRAL BURYING GROUND

While the nearby Granary Burial Ground earns top billing thanks to its Freedom Trail–friendly names, including Paul Revere, Samuel Adams, John Hancock and even Mother Goose, the Boston Common's lesser-known Central Burying Ground has something that the other graveyards don't: ghosts. After Boston's Puritan leaders purchased the plot in 1756, the cemetery was used as a final resting spot for foreigners and other paupers who couldn't cough up enough shillings for a proper burial. The graveyard is the resting spot for composer William Billings and artist Gilbert Stuart, who was responsible for painting George Washington's mug on the dollar bill. It is also reportedly the place where the see-through denizens from the Common's spirit realm prefer to hang out.

"Visitors to the graveyard have reported seeing shadowy figures appear nearby, often near trees," wrote Christopher Forest in *Boston's Haunted History*. "The figures disappear or dissolve when people look right at them. Some

The more notorious haunting at the Central Burying Ground in the Boston Common centers on a young female spirit who was described as a teen girl "with long red hair, sunken cheekbones and a mud-splattered gray dress on." *Courtesy of the Boston Public Library, Print Department.*

people have associated the figures with the former hanging victims who met their end on the Boston Common gallows."

Apparently, the cemetery's spirits like to have fun with tourists. "They have been accused of poking people in the back, rattling keys and even brushing up against shoulders. Some people roaming the graveyard have reported being grabbed from behind by an unseen force," he wrote.

Jeffrey Doucette, a veteran tour guide with Haunted Boston, said he was a skeptic until he witnessed a woman have a close encounter with a paranormal force outside the cemetery's gates in 2011. "She felt someone or something tap her on the shoulder," he mused. "She looked annoyed, and I had to assure her that no one was there."

The more notorious haunting at the Central Burying Ground centers on a young female spirit who was described by late great ghost expert Jim McCabe as a teen girl "with long red hair, sunken cheekbones and a mud-splattered gray dress on." On a rainy afternoon in the 1970s, she paid a visit to a dentist named Dr. Matt Rutger, who reportedly experienced "a total deviation from reality as most of us know it." According to Nadler's *Ghosts of Boston Town*, Rutger was checking out the gravestone carvings. He felt a tap on his shoulder and then a violent yank on his collar. No one was there.

As Rutger was bolting from the cemetery, he noticed something out of the corner of his eye. "I saw a young girl standing motionless in the rear corner of the cemetery, staring at me intently," he said. The mischievous spirit then reappeared near the graveyard's gate, almost fifty yards from the initial encounter. Then the unthinkable happened. "He somehow made it by her to Boylston Street, and even though he couldn't see her, he felt her hand slip inside his coat pocket, take out his keys and dangle them in midair before dropping them," McCabe recounted.

Rutger, in an interview with Nadler, said the '70s-era paranormal encounter has left an indelible mark on his psyche. "One thing is certain, the encounter affected me in very profound ways," he reflected. "As a trained medical professional, I have always seen the world in fairly empirical terms. There's no way something like that cannot completely change how you think about the world."

Adam Berry, winner of Syfy's *Ghost Hunters Academy* and a noted paranormal investigator from *Ghost Hunters*, said he visited the Central Burying Ground in 2004 to exorcise a spirit that was haunting his dorm room during his junior year at the Boston Conservatory. "My mother told me to take some dirt from the front of my dorm and throw it in the cemetery," he recalled. "We did and dumped the dirt in the old cemetery

near Emerson [Central Burying Ground] to get rid of the spirit." When asked if he felt a paranormal presence at the old cemetery near Emerson, the twenty-nine-year-old investigator said he did.

Based on his experience in 2004, Berry said that he would put Boston's Central Burying Ground at the top of his most-haunted list. "That cemetery definitely has an appeal, like all old cemeteries. There's so much history there in that space, and walking through you get a sense that each gravestone is talking to you. The older the cemetery, the more intimidating. I would definitely put that cemetery at the top of my list."

File under: teen spirit

Great Elm Site

When a violent windstorm swept through Boston on February 15, 1876, the historic Great Elm fell to the ground with a dramatic crash that splintered its venerated branches into a thousand little pieces and exposed the roots of Boston's dark past. Revered as a local symbol of patriotic unity and known as "Boston's oldest inhabitant," the Great Elm topped seventy-two feet and shielded the nearby powder house located on the slope called Flag Staff Hill, which was used by British redcoats during the Revolutionary War and later by American troops during the War of 1812. Hearing the loud boom of the tree echo throughout the Common, locals flocked to the site and "attacked the venerable ruin and secured mementos," reported the *Boston Daily Globe*. "While some were content with very small fragments," others returned to

A small plaque marking the Great Elm's former location in the Boston Common calls it a spot where the "Sons of Liberty assembled." No mention of the tragic tree's victims, like Ann "Goody" Glover, who were hanged for various crimes by the Puritans. *Photo by Ryan Miner.*

the scene several times, picking apart the landmark with a maenadic ferocity. The frenzy, which echoed a particularly dark time in Boston's past, was emblematic of the bread-and-circus hysteria that occurred there less than two hundred years prior.

The Great Elm was also known as the hanging tree where Boston's alleged witches, rakes and rogues met their untimely death. For the record, the Common's gallows were moved in 1769 to an area near the current subterranean parking lot over by Charles Street. "Tradition says that it early attained the unenviable distinction of the hanging tree, and it is surmised that in the days of witchcraft delusion Ann Hibbins met an ignominious death upon it in 1656, and was followed by many other unfortunate victims," reported the *Boston Daily Globe* in 1876.

Many of the tragic tree's victims, like Ann "Goody" Glover, were executed for ridiculous reasons. Glover, a self-sufficient, strong-willed Irishwoman who spoke fluent Gaelic, lived in the North End, where she washed laundry for John Goodwin and his family. After a spirited spat in her native Gaelic tongue with Goodwin's thirteen-year-old daughter, Martha, Glover was accused of bewitching the four children in the household and was sent to prison for practicing the dark arts. Reverend Cotton Mather, who was a major player in the witch trials in Salem, wrote that Glover was "a scandalous old Irishwoman, very poor, a Roman Catholic and obstinate in idolatry." During her trial, Glover was asked to recite the Lord's Prayer. Speaking in broken English, she only knew the Catholic version and not the Puritan Protestant prayer. She was hanged in the Common on November 16, 1688. Glover was one of four women who were accused, and executed, for witchcraft over a forty-year period beginning with the execution of Margaret Jones in 1648.

A small plaque marking the Great Elm's former location calls it a spot where the "Sons of Liberty assembled"—no mention of the hangings. However, visitors to the site near the Frog Pond leading up to the Soldiers' and Sailors' Monument insist that many victims of the gallows have left a supernatural imprint in the area near Flag Staff Hill.

"Exactly who these people are is uncertain," wrote Christopher Forest in *Boston's Haunted History*, referring to the alleged ghosts from the gallows roaming the Common. "People have spotted images of the victims hanging from trees or wandering near the area where the Central Burying Ground is kept."

Leslie Rule, the daughter of prolific crime writer Ann Rule, commented in her book *When the Ghost Screams* that a worker at L.J. Peretti Co. Tobacconists "has heard the inexplicable rattle of chains in the early morning when

he is alone in the building. The metallic clanks emanate from the empty basement, where there is no reasonable explanation for the sound." What's the significance of chains? Rule believes that the noise echoing in the basement of the nearby Boylston Street tobacco shop is somehow tied to the chains used to shackle the women accused of witchcraft and others executed at the hanging tree.

In addition to the inexplicable sounds and shadows, a female specter has been seen wearing Puritan-era attire, weeping and sometimes screaming. Adam Berry said it's possible that the residual energy surrounding the Great Elm site is left over from the seventeenth-century hangings. In the past, Berry said that he's heard "reports of women wailing or crying. They're in grief. It's possible that something traumatic has happened and they've died or they're searching for their son or a soldier."

Or perhaps it's Goody Glover, who was finally exonerated from all charges of witchcraft in 1988, giving folks a piece of her mind one last time.

File under: gallows ghost

Mary Dyer Statue

Mary Dyer, targeted by the Boston Puritans for being a Quaker and immortalized as an eerie bronze statue in front of the Massachusetts State House, was one of several anti-Puritan martyrs persecuted in the Boston Common because of their religious beliefs. Dyer, one of the first settlers of Boston, appeared in 1634 as an outspoken critic of Protestant Puritanism. She advocated her Quaker beliefs to the colonial settlers and was dead set on exposing the hypocrisy of the era.

After spending years practicing her faith in Rhode Island, Dyer returned to Boston in 1658 and began preaching in the streets and defending her religion. The Puritans exiled Dyer, but after one year, she doggedly made the trek back. Dyer traveled to Boston for a third time with two Quaker men, William Robinson and Marmaduke Stephenson, and was immediately seized by authorities. The judge condemned her and the two men to death by hanging, which was carried out at the infamous gallows tree in the Boston Common. Many locals, including her son, contested the ruling, and Dyer was given a last-minute reprieve from the governor. According to lore, she had the hangman's noose around her neck when the execution was called off.

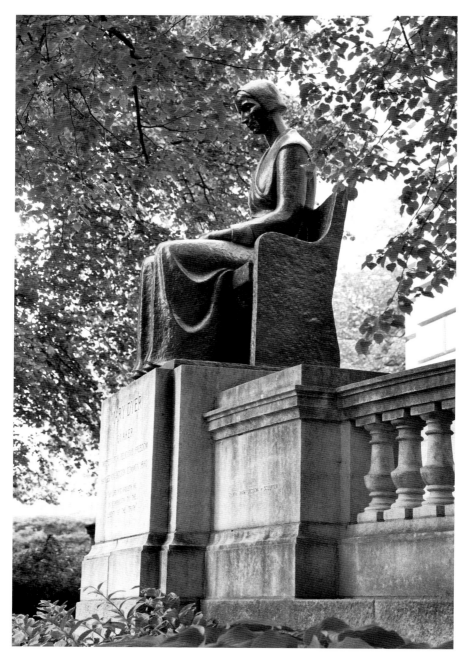

Mary Dyer, targeted by the Boston Puritans for being a Quaker and immortalized as an eerie bronze statue in front of the Massachusetts State House, was one of several anti-Puritan martyrs persecuted in the Boston Common because of their religious beliefs. *Photo by Ryan Miner.*

Dyer was sent to Rhode Island and returned to Boston after two months. She was escorted to the gallows by Captain John Evered and was asked to repent. Her response, recalled by Edward Burrough in his 1661 account of early American Quakers, was: "Nay, I came to keep blood guiltiness from you, desiring you to repeal the unrighteous and unjust law made against the innocent servants of the Lord. Nay, man, I am not now to repent." Dyer was hanged on June 1, 1660, and was buried in an unmarked grave somewhere in the Boston Common. The bronze statue of Dyer sits solemnly in front of the State House on Beacon Street and looks eerily out at the public park where she was unjustly hanged and buried.

Remember the reports of the wailing woman apparition wearing colonial-era garb? Several accounts imply that Dyer's spirit still roams the Common. "A woman wearing a Puritan dress, sometimes weeping, has been spotted walking the Common," Christopher Forest wrote in *Boston's Haunted History*. "Some witnesses even believe that Mary Dyer herself has materialized at times."

In the June 21, 1894 edition of *The Independent*, a New York City–based weekly, writer Henry Austin presented a literary version of what he calls a long-forgotten Boston legend, that of the White Witch of the Common, who apparently first made a dramatic appearance on June 1, 1750. She "spoke to a man of great talent, who in the broad mid-noon was reeling along the Common very drunk," Austin wrote. "What she said the great man would not reveal, even to his wife; but it sobered him forever. Never from that day did he touch wine even."

In Austin's story, which is set at a bench near the current Boylston station just feet away from the Central Burying Ground, he talked about the roots of the tall tale. "I do remember, however, hearing in my boyhood something about the Witch of the Common, yet according to my impression she was not considered a Quaker but a very merry hag who played mischievous pranks, such as casting some grave and reverend senator into a deep sleep on one of these benches and then causing a stupid watchman to arrest him on the charge of intoxication or vagrancy."

Austin believed that the woman, who appeared "every twenty-five years to inspire some man or woman or boy or girl with the desire, which is half the power, of living a noble life," was Mary Dyer. Based on the nineteenth-century legend, the "Quaker martyr" was an anniversary ghost, a spirit who returns at a significant date to reenact a historical event.

Adam Berry told me that there's usually a tragedy attached to an anniversary ghost. "If on June 1, every twenty-five years, there's this woman who comes out and it really happens and people can see her, that would be a residual haunt,"

Berry said. "If it happens once [every] so often at the same time of year, it could be based on her death or something in her life that she's reliving."

Hanged in the Common because of religious intolerance? Yep, that qualifies. Based on the ghost of the Common legend, Dyer's next appearance is slotted for June 1, 2025.

File under: scary Mary

PARKMAN HOUSE

The Parkman Bandstand, located in the center of the Boston Common and erected posthumously after the "crime of the century" involving the heinous murder of Dr. George Parkman, stands as a solemn reminder of one of the most talked-about trials of the 1800s. *Courtesy of the Boston Public Library, Print Department.*

One of the most heinous crimes from Boston's past centers on Dr. George Parkman, who was beaten and dismembered in a Harvard Medical College laboratory in 1849. Based on a bizarre plumbing accident that occurred on November 23, 1999, exactly 150 years after Parkman's macabre murder, his spirit is rumored to haunt the house that bears his family name. It faces the Boston Common and is located at 33 Beacon Street. Also, the Parkman Bandstand, located in the center of the public park and erected posthumously after the "crime of the century," stands as a solemn reminder of one of the most talked-about trials of the 1800s. It's a tale of a $400 loan turned deadly.

Hailing from one of the most prominent families in Boston, Parkman was a retired doctor who became a landlord and money lender in the early 1800s. Nicknamed "Old Chin," Parkman befriended one of his clients, John White

Webster, who was a professor of chemistry and geology at Harvard Medical College. Incidentally, the Parkman family donated a large sum of money to fund Harvard's medical school, which was formerly located near the Mass General Hospital.

Webster borrowed $400 from Parkman, who was reported missing days following an attempt to collect his money. Bostonians were on the hunt for the missing landlord, and police printed twenty-eight thousand missing-person fliers. After a sensational trial and Webster's eventual confession, the press had a field day spitting out "Harvard Professor and Murder" headlines guaranteed to captivate the city. On August 30, 1850, the professor was hanged at the gallows.

How did Webster murder Parkman? After an unexpected collections call at Webster's laboratory, the professor took his walking stick and clubbed Parkman in the head during a momentary fit of rage. Panicked, Webster reportedly chopped up the body into pieces and threw the remains into the privy, also known as a toilet.

In his confession, Webster claimed that it was an act of self-defense. He said that Parkman "was speaking and gesticulating in the most violent and menacing manner" about the loan. In response, Webster "seized whatever thing was handiest—it was a stick of wood—and dealt him an instantaneous blow with all the force that passion could give it. It was on the side of his head, and there was nothing to break the force of the blow. He fell instantly upon the pavement. There was no second blow. He did not move."

During the trial, a police officer testified that Parkman's torso was found in a bloodstained tea chest, which was displayed to the court. Webster also allegedly burned Parkman's bones, including his jawbone complete with false teeth, in the furnace. The officer also said that it was possible to fit the victim's remaining body parts in the toilet, but the torso wouldn't fit.

So when Parkman's former home on Beacon Street was destroyed in a plumbing accident in 1999, historians and paranormal experts weren't surprised. Just days before the house was due to host the mayor of Boston, a cistern was broken in a third-floor toilet at the Parkman House and the tank overflowed. "The water was gushing everywhere. It was the worst possible scenario. The toilet on the third floor was broken and the water kept running and running and running, and the water leaked down to the second floor and then the first floor, so there was quite a bit of damage," said Cecily Foster, who oversaw the Parkman House and was director of tourism, in a *Boston Globe* article. "Maybe the ghost of Dr. Parkman came to visit last night."

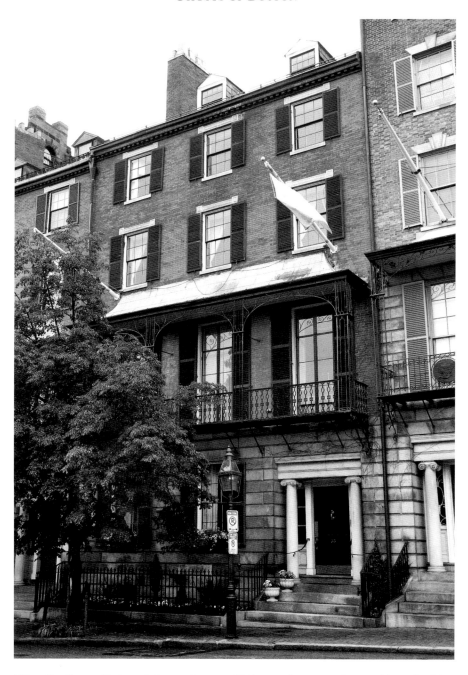

When Dr. George Parkman's former home at 33 Beacon Street was destroyed in a plumbing accident in 1999, historians and paranormal experts weren't surprised. Some believe that Parkman's ghost may have returned to his Beacon Hill brownstone. *Photo by Ryan Miner.*

Perhaps he did. The late Jim McCabe, who was a noted ghost lore expert and owner of New England Ghost Tours, explained why Parkman may have returned to his Beacon Hill brownstone. "The old Yankees may have been strange in certain ways, but they kept the old buildings, which has made it attractive to many visitors—even ghosts," McCabe told the *Globe*. "Spirits are attracted to the places they lived in. I think what attracts ghosts up here is that you don't tear down the buildings."

Charles Dickens, who was intrigued by the infamous murder, paid a visit to Webster's laboratory eighteen years after the trial. His response to the murder scene? The *Christmas Carol* and *Great Expectations* author said that "the room smelled as if the body was there." Based on the freakish plumbing disaster marking the 150-year anniversary of Parkman's death, Dickens should have checked out the murdered doctor's palatial Beacon Hill estate.

Yes, fact is stranger than fiction.

File under: phantom flush

HARBOR HAUNTS

There are ghosts lurking in the waters near the Hub's historic seaport and inhabiting the handful of secluded islands scattered throughout the Boston Harbor. "Over the past four centuries, dozens of islands that dot Boston Harbor have seen plundering pirates run aground, major battles won and lost, prisoners confined, and thousands felled by war and disease," wrote George Steitz in *Haunted Lighthouses*. He added that the body of water surrounding the "beacon upon a hill" is arguably America's most historic and, perhaps, most haunted. "The aftermath may have left the surrounding waters brimming with restless spirits."

Since 1716, ships have passed one of the oldest lighthouses in America, the Boston Light, which stands as an eerie sentinel, guarding the secrets of the mainland's not-so-Puritanical past. "I think people do feel a presence of spirits out there," said Holly Richardson, an officer of the Metropolitan District Commission, en route via ferry to the site of the lighthouse on Little Brewster Island. "It's a magical feeling. It's a place for one's imagination to wander." According to Steitz, hundreds of sudden, tragic deaths have occurred in the murky waters surrounding the historic lighthouse. Rick Himelrich, who worked with the U.S. Coast Guard, talked to Steitz about a ghost sighting that occurred decades ago near the Boston Light's living quarters: "The figure of a woman walked right by them. Plain as day. There were two gentlemen sitting there and they both saw her. She walked right by them." The odd thing? There were no women at the lighthouse that day. At least "not one who was a living, breathing human," the officer added.

The oldest commissioned naval vessel still afloat, the USS *Constitution*, is berthed at the Charlestown Navy Yard's Pier I in the inner waterway of the Boston Harbor. The supernatural imprint of Old Ironsides' casualties of war allegedly continues to haunt the legendary vessel. *Courtesy of the Boston Public Library, Print Department.*

Himelrich's tale is one of several accounts of wailing female specters and seafaring shadow figures reported to haunt the famed Boston Harbor Islands. There's the more notorious Lady in Black apparition who has been spotted creeping along the ramparts of Fort Warren on Georges Island since the Civil War. On January 18, 1644, a crew of three sailors watched in awe as a strange set of lights emerged from the chilly waters and transformed into the shape of a man near what was Governor's Island, currently an extension of Boston's Logan Airport. On Nix's Mate, one of the harbor's smallest islands, there are reports of a salty-dog specter known as William Fry, who was executed in the 1700s and hanged by the noose, which he is said to have tied himself. Sailors who pass by the tiny, off-limits Nix's Mate claim to hear bloodcurdling screams and maniacal laughs from the island, which was once used as a makeshift prison and burial ground.

"Boston may have been a beacon on a hill, but it cut its teeth by the sea," wrote Christopher Forest in *Boston's Haunted History*. "While Boston's waterways have been home to a flurry of activity, they have also been home to an array of local lore. The famed Boston Harbor islands alone are a virtual treasure trove of ghostly tales."

Two if by sea? Only a handful of the Boston Harbor Islands are accessible by ferry. Because of its water-bound proximity, much of Boston's spooky maritime past has been lost at sea. However, a few ghostly tales have surfaced over the years, like long-forgotten messages in bottles, from the Boston Harbor's frigid and apparently haunted waters.

GEORGES ISLAND'S FORT WARREN

One of Boston's most notorious hauntings centers on the ghost of a Confederate prisoner's wife who was sentenced to death for aiding in the escape of a soldier when Georges Island's historic Fort Warren served as a Civil War lockup. According to the legend popularized by historian Edward Rowe Snow, a gun-toting Southern woman disguised herself as a male prisoner, snuck into the fort in an attempt to free her newlywed husband and managed to infiltrate his cell. When the duo was approached by Fort Warren's Colonel Justin Dimick, the wife haphazardly fired her pistol and killed her husband instead. When the gutsy woman from North Carolina was sent to the gallows, her last request was to wear female clothing, which came in the form of a makeshift black robe whipped together by Union soldiers. She's known as the Lady in Black.

Located seven miles offshore from downtown Boston, Georges Island is one of the more popular stops on the Boston Harbor Islands ferry and was used as farmland before it was acquired by the government for coastal defense. Built in 1847, the island's Fort Warren is a ghostly, pentagonal-shaped granite structure once used as a training camp, a sentry post and a prison for Confederate soldiers during the Civil War. It also defended Boston

One of Boston's most notorious hauntings centers on the ghost of a Confederate prisoner's wife who was sentenced to death for aiding in the escape of a soldier when Georges Island's historic Fort Warren served as a Civil War lockup. She's known as the Lady in Black. *Courtesy of the Boston Public Library, Print Department.*

during the Spanish-American War and through World Wars I and II before it was decommissioned in 1947.

The first Confederate war prisoners arrived at Fort Warren on October 31, 1861. Colonel Dimick, a West Point graduate and Mexican War veteran, was anticipating 150 prisoners. According to newspaper reports in 1861, more than 800 Confederate soldiers arrived at the ill-prepared Fort Warren, and a feeling of "pity rather than…hatred of the visitors" was exacerbated by the distressed state of the fort. Despite the less-than-stellar conditions, Dimick was lauded for his humane treatment of the prisoners, while Bostonians rallied to help with food rations and bedding, hoping that the Union war prisoners would receive equally hospitable care.

However, the so-called Lady in Black didn't fare so well. According to Snow's story reprinted in Jay Schmidt's book *Fort Warren*, "Colonel Dimick had no alternative but to sentence her to hang as a spy." Snow's legend recounted several sightings of the black widow apparition. Three nineteenth-century soldiers noticed mysterious footprints in the shape of a girl's shoe in the snow. In 1934, a sergeant reportedly heard a female voice warning him, saying, "Don't come in here!" when he approached the fort's dungeon area. Soldiers on sentry duty shot at ghost-like apparitions, claiming that they were chased by the lady of the black robes. Guards stationed at the fort during World War II would taunt new recruits when it was time for duty, telling the newbies to "watch out for the Black Widow!" The *Gloucester Telegraph*, in January 1862, reported that soldiers spotted a supernatural presence of an old woman who was "vindictively frisking about the ruins of an old building from which she was ejected some time previous to her death."

Gerard Butler, a former curator at Fort Warren during the '70s, told Schmidt in an interview that he had a few paranormal encounters while living on Georges Island. "He heard the distinctive clicking sounds of footsteps coming toward him along the ramparts," Schmidt wrote in *Fort Warren*, adding that Butler's wife and daughter were both asleep during the alleged incident. Butler also said that a police dog stationed at the fort in the late '60s was afraid of the structure's Bastion A area. "The dog would go anywhere in the fort, but once it got to Bastion A, the dog *would always* refuse to go inside," Butler recounted. In 1981, a crew of Civil War reenactors saw a dark shadowy figure creeping in the night and watched in awe as a lantern levitated through the ramparts without a living person holding it.

To add to the Lady in Black mystery, there are no recorded accounts of a woman being hanged as a spy. In fact, there are similarly no reports of Confederate soldiers or sympathizers being executed at Fort Warren

during the Civil War. However, most of the paperwork documenting Fort Warren's haunted past was destroyed when the military compound was decommissioned after World War II.

However, Butler said a crew of Massachusetts Institute of Technology (MIT) students may have conjured up the lady of the black robes in the mid-1970s. He recalled seeing a photograph shot by MIT students who set up a camera at Fort Warren's Scarp Gallery to record paranormal activity. The former curator said that one photo strangely resembled the so-called Lady in Black. "It did look as if there was a woman apparition facing the camera with a sun bonnet and shawl," he said, adding that "it could have been air currents or a fog or something." Butler even mused that the photo may have been one of MIT's infamous hacks or "a mild hoax for intra-office chuckles" at the university.

Or it could have been the residual spirit of the Lady in Black taking her nightly stroll along the fort's ramparts in search of the man she murdered by mistake.

File under: widow's walk

Little Brewster's Boston Light

There's a something-wicked-this-way-comes mystique radiating from Little Brewster's Boston Light, which is approximately nine miles offshore from downtown and dates back to 1716. It was rebuilt in the eighteenth century after the redcoats torched the original structure during the Revolutionary War. It's the second-oldest working lighthouse in the country, and its ninety-eight-foot-high tower has seen almost three centuries of tragedy, starting with the death of the light's first keeper, George Worthylake, who drowned alongside his wife, daughter and two other men when their boat capsized a few feet from the island's rocky terrain in 1718.

The ghosts from the Boston Light's early days have captivated the imagination of the city's land-bound inhabitants for years. A young Benjamin Franklin, then an up-and-coming printer, penned a ballad about the Worthylake incident called "Lighthouse Tragedy," which he later dismissed as "wretched stuff" but joked that it "sold prodigiously." Boston Light's second keeper, Robert Saunders, met a similar fate as Worthylake and drowned only a few days after taking the job. The tower, which originally stood at seventy-five feet high, caught fire in 1751, and the building was damaged so

Little Brewster's historic Boston Light, which is approximately nine miles offshore from downtown and dates back to 1716, has withstood blizzards, erosion, fires, lightning, shipwrecks and ghosts. *Courtesy of the Boston Public Library, Print Department.*

intensely that only the walls remained. The British, angry that the colonists tried to disengage the beacon during the Revolution, apparently destroyed Boston Light in 1776 while heading out of the Boston Harbor. It was rebuilt in 1783 but witnessed several more tragedies, including two shipwrecks, the *Miranda* in 1861 and the *Calvin F. Baker* in 1898, which resulted in three crewmen freezing to death in the rigging. In addition to the onslaught of natural disaster, one keeper in 1844 set up a "Spanish" cigar factory, carting in young girls from Boston and claiming that the stogies sold in the city were foreign imports. Captain Tobias Cook's clandestine cigar business was quickly fingered as fraudulent and shut down.

President John F. Kennedy legislated that the Boston Light would be the last manned lighthouse in the country. It has been inhabited for almost three centuries, even when the tower was automated in 1998. One island mystery, known as the Ghost Walk, refers to a stretch of water several miles east of the lighthouse where the warning sounds from the tower's larger-than-life foghorn cannot be heard by passing ships. For years, no one has been able to scientifically explain the so-called Ghost Walk's absence of sound, not even

a crew of MIT students sent in the mid-1970s to spend an entire summer on the island but who were still unable to crack the case.

However, talk of the paranormal has trumped the island's Ghost Walk mystery. "It has withstood blizzards, erosion, fires, lightning, shipwrecks and ghosts," mused a report in the April 29, 1999 edition of the *Boston Globe* that profiled Little Brewster's Chris Sutherland from the U.S. Coast Guard. Apparently, the petty officer noticed tiny human footprints in the snow while keeping the light in the late '90s. "I'm not saying it's a ghost," he said, "but I don't know. In the past, there were kids out here, lightkeepers' families. There were shipwrecks along the rocks."

A former Coast Guard engineer who lived on the island in the late '80s, David Sandrelli, told the *Globe* that there have been reports of a lady walking down the stairs. Also, he said that crew members stationed on Little Brewster would hear weird noises in the night but would dismiss them, saying, "It's just George," an allusion to the ghosts from the Worthylake tragedy.

Sally Snowman, who was the first female keeper at the last occupied lighthouse in the country, told the *Globe* in 2003 that she encountered a few "just George" moments during her stint on Little Brewster. "I won't say if I believe or don't believe in any ghosts on the island," she said. "Let's just say I've heard plenty of stories. Some strange things do happen out here, like the fog signal, which works on reading moisture in the air, going off at 3:00 a.m. on a star-filled night. That's fun because you have to walk across the island to shut that sucker off. That can be weird."

Little Brewster's mascot black Labrador, Sammy, reportedly had a close encounter in 1999. "He would stand up, run out of the room for no reason and was shaking all over," recalled a former keeper, Gary Fleming. "It really does get spooky. You have plenty of time here, and if you let your mind go, you can freak yourself out," Fleming said, adding that he believes in the supernatural.

Snowman echoed Fleming's comments about the canine mascot's odd nightly ritual. "He's been out here six years, and at dusk every night he barks and barks," she mused. "We call it the Shadwell Hour, after the slave who died."

So who's Shadwell? Mazzie B. Anderson, a woman who was stationed with her husband on Little Brewster in 1947, recalled hearing footsteps when no one was there and watching the foghorn engines magically start themselves when her husband was ill. She also heard maniacal laughter followed by the sobs of a female voice yelling, "Shaaaadwell, Shaaaadwell!" It turns out that Worthylake, his wife and their youngest daughter capsized

near the island, and the oldest daughter, who was left behind with her friend Mary Thompson, sent out a rescue party, which included an African American slave, to save her drowning family. "Somehow the canoe capsized and all went overboard," wrote Anderson in the October 1998 edition of *Yankee* magazine. "The African made a valiant attempt to save all hands, but failed. The young girl was the last to go under, still calling his name. No one survived."

The name of the courageous African American slave? He was known as Shadwell.

File under: shutter island

USS CONSTITUTION

The oldest commissioned naval vessel still afloat, the USS *Constitution*, is berthed at the Charlestown Navy Yard's Pier I in the inner waterway of the Boston Harbor. Launched in 1797 and often referred to as "Old Ironsides" because of its uncanny ability to repel shots fired during wartime battles, the massive wooden-hulled, three-masted frigate serves as the official ambassador for the United States Navy and is a throwback to the glory days of the War of 1812, when Old Ironsides defeated five British warships and captured numerous merchant vessels.

As a featured stop on Boston's highly trafficked Freedom Trail, the USS *Constitution* greets thousands of tourists daily and is a floating national treasure. It is, in essence, living naval history. However, this isn't a history that lies in a shallow grave. The blood of the fallen sailors that once stained the deck of the two-centuries-old frigate may have washed away over time, but the supernatural imprint of Old Ironsides' casualties of war allegedly continues to haunt the legendary vessel.

According to former crew members, the USS *Constitution* is a ghost ship. "We took ghosts so seriously on the *Constitution*," said Pete Robertson, a first-class petty officer who served aboard the ship from 2001 to 2004, in an interview with *Stars and Stripes*. "Unless you were a brand new crew member, you didn't mess around with that stuff. You didn't make jokes about it…You didn't even try to scare each other because people were terrified. A lot of people were terrified to stand watch on the ship." Robertson remembered seeing objects mysteriously move on deck, like a twenty-four-pound cannonball, while the ship was completely still. "It was moving in ways a

As a featured stop on Boston's highly trafficked Freedom Trail, the USS *Constitution* greets thousands of tourists daily and is a floating national treasure. According to former crew members, the USS *Constitution* is a ghost ship. *Courtesy of the Boston Public Library, Print Department.*

cannonball just shouldn't move," he said, adding that the odd motion was scientifically inexplicable.

Allie Thorpe, a former seaman serving between 2002 and 2005, echoed Robertson's experiences with paranormal activity while on board. "It would feel like there was somebody there with you," Thorpe explained. "It would feel like somebody was walking up behind you and blowing on your neck."

In an attempt to investigate the reports of alleged spirits, Lieutenant Commander Allen R. Brougham set up a camera overlooking the *Constitution*'s wheel one evening in 1955. "At about midnight, the figure of a nineteenth-century navy captain appeared long enough to be captured on film," one report claimed. "The picture shows a man in gold epaulets reaching for his sword."

Spirits on deck? No surprise. As a major player in a series of nineteenth-century maritime battles, the *Constitution*'s shiny façade has been marred by the blood of former tenants.

Dorothy Burtz Fiedel, author of *Ghosts and Other Mysteries*, recounted a particularly dark chapter in Old Ironsides' history dating back to December 1884, when forty-three crew members became ill with fever and dysentery. Several died, including one man who was found on deck trying to crawl to sick bay. In addition to the American naval casualties, several of the ship's prisoners of war were fatally wounded, including Captain Henry Lambert from the British Royal Navy, who was annihilated by a musket ball and passed away from the injuries on January 3, 1813.

Fiedel interviewed former crew members, and a few talked about a haunted cot suspended by chains in the ship's sleeping section, or the berthing area known as the rack. "Apparently, some of the sailors, who got stuck with that particular rack, refused to sleep in it and slept on the floor. One sailor, who braved the rack, woke up in the middle of the night…and he beheld the disembodied head of a normal-sized man. The face was pale, lifeless looking and…the form faded out around the neck area." One man encountered a phantom falling from the crow's nest, while others, similar to Officer Robertson's account in *Stars and Stripes*, heard cannonballs rolling around on deck, even though they were all welded together.

Gary Kent, a former crew member on the *Constitution* in the '80s, described one late-night incident involving a residual haunting of a man dressed in an old-school uniform: "His jacket was black-bluish in color with gold buttons…I immediately noticed the blood on his face. He had blood on his jacket." Kent said the three other men in the rack also saw the apparition, which he described as "foggy, frosty and fuzzy," before it faded away.

While Kent's recollection of the ghostly sailor has lost its fear factor over time, the former officer said he is haunted by one strange thing he observed while serving on the *Constitution*: "Birds never landed on the ship…There were a lot of high places for them to perch, but I never saw one land. I was very new to ships…The old-timers, though, they thought it was very strange…It was very strange, definitely not normal."

Incidentally, Kent's account of a sailor wearing a black-bluish jacket with gold buttons mirrors that in a photo taken in 1955 by Lieutenant Captain Brougham. According to lore, the ghostly figure is a residual spirit of Commodore Thomas Truxton, the first man to command the *Constitution* in the late 1700s. He was known as a particularly harsh disciplinarian who reportedly tortured one sailor, Seaman Neil Harvey, as a cautionary tale of sorts after he fell asleep while manning the ship's deck. The murder was brutal; Harvey was stabbed in the gut, tied over the ship's cannon and blown to smithereens.

Perhaps Harvey's spirit is responsible for mysteriously moving the cannonballs on the ship's deck and waking up crew members in the wee hours of the night. Maybe it's a supernatural warning meant to protect the sleeping sailors from a fate worse than death—being tied to the end of the *Constitution*'s loaded cannon and blown into a thousand little pieces while all hands on deck watched in horror.

File under: loose cannon

HOTEL HAUNTS

Hotels where guests check in but don't check out? In Stephen King's *The Shining*, chef Dick Hallorann explained to the young Danny Torrance why the ghosts from the fictional Overlook Hotel continued to linger. "I don't know why, but it seems that all the bad things that ever happened here, there's little pieces of those things still laying around like fingernail clippings," he warned. Past traumatic events like murders and suicides can leave a supernatural imprint on a building, according to the telepathic chef.

When it comes to hotels replete with paranormal residue, Boston isn't immune. In fact, the recently refurbished Omni Parker House, arguably the most haunted hotel in New England since opening its doors in October 1855, is a regular hangout for horror writer King when he makes the trek to Boston for Red Sox games. Incidentally, the hotel's creepy room 303 is rumored to have inspired King when he wrote the short-story-turned-film "1408," which follows a man who makes a career out of debunking paranormal activity and finds himself in the cursed room.

The Parker House doesn't exactly shy away from its ghostly reputation, considering that there's a page devoted to "haunted tales" on its website. It has been home to various sightings of the misty apparition of the hotel's founder, Harvey Parker, who reportedly has been spotted roaming the tenth-floor annex, checking up on unsuspecting guests. Other spooky happenings involve elevators mysteriously being called to the third floor—once frequented by both Charles Dickens and Henry Wadsworth Longfellow. That's also where stage siren

The Omni Parker House, 60 School Street, is arguably the most haunted hotel in New England since opening its doors in October 1855. It boasts a slew of ghostly reports, including several from the hotel's founder, Harvey Parker. *Courtesy of the Boston Public Library, Print Department.*

Charlotte Cushman and an unnamed businessman died. In fact, one third-floor guestroom—yes, the mythic room 303—was converted into a closet after the unexplained reports of raucous laughter and the smell of whiskey spooked management.

Holly Nadler, author of *Ghosts of Boston Town*, speculated as to why the historic hotel is a hotbed of alleged paranormal activity. "With all of those layers of history, all the tens of thousands of people who've lived, loved, partied, won acclaim, plotted assassinations, dropped face-first in Charles Dickens's punch bowl and, yes, died there, you're bound to get a number of continuously operating ghosts."

Of course, the Omni Parker House isn't the only overnight lodging in Boston with reported supernatural activity. Several of the Hub's alleged haunted dorms highlighted in the "Campus Haunts" chapter, including Boston University's Shelton Hall and Berklee College of Music's 150 Massachusetts Avenue, had former lives as hotels. The Charlesgate, Emerson College's "devilish dormitory" that has been converted into upscale condominiums, was built in 1891 as a fin de siècle hotel and boasted upscale accommodations for Boston's elite and then deteriorated during the Depression before housing college students.

Elliott O'Donnell, an Irish author who became an authority on the supernatural during the early 1900s, wrote about a close encounter at a no-name hotel in Boston with "an undeniable reputation for being haunted" in his book published in 1917 called *Experiences as a Ghost Hunter.* "I only stayed in town two nights," he wrote, not citing a specific location. "It was

in a rather poor neighborhood, at least poor for Boston, and there were few visitors." O'Donnell, who had an uncanny ability to embroider fact with a grandiose flair for fiction, allegedly chatted with the night porter about the hotel's elevator, which had a mind of its own. "A visitor arrived here late one night and was found by the day porter dead in the lift," the porter recalled. "How he died was never exactly known. It was rumored he had either committed suicide or been murdered…Since then that elevator has taken into its head to set itself in motion at the same time every night."

Haunted elevators? Yep, it's a recurring theme at the handful of spirited hotels where visitors stay a few decades or so beyond check-out time.

HAMPSHIRE HOUSE

Located above one of Boston's more iconic watering holes, the former Bull and Finch Pub, which changed its name to its popular TV namesake *Cheers* after serving as inspiration for the 1980s sitcom, the Hampshire House is a five-story Georgian Revival town house built by Brahmin architect Ogden Codman. The Hampshire House—which initially served as a private residence for Judge Bayard Thayer, his wife, Ruth, and their children—was built in 1910 and became the centerpiece for Beacon Hill's turn-of-the-century elegance, boasting killer views of the Boston Public Garden and hosting lavish, black-tie parties for the Hub's "beacon upon the hill" elite. The Victorian mansion's tall Palladian windows, crystal chandeliers and carved-oak paneling were aesthetically matched with a breathtaking spiral staircase that ascended to the heavens—and is where Thayer's twelve-year-old twin daughter allegedly hanged herself with a bedsheet in 1912.

Yep, the former luxury hotel located at 84 Beacon Street atop the famed *Cheers* bar might be a place where at least one ghost knows your name.

"While one of the girls appears to have lived a happy life, the other daughter apparently suffered from some type of emotional disability," wrote Christopher Forest in *Boston's Haunted History*. "During one of her bouts, she reportedly tied a noose using bed sheets and hanged herself from a large spiral staircase in the house. Rumors have surfaced as to what turmoil may have caused this young girl to commit suicide, but no one truly knows the reason. As time went on, and though the Thayers moved from the house, the young girl's spirit lingered on."

Hampshire House, the former luxury hotel located at 84 Beacon Street atop the famed *Cheers* bar, might be a place where at least one ghost knows your name. The resident teen spirit allegedly hanged herself with a bedsheet from the building's breathtaking spiral staircase. *Photo by Ryan Miner.*

Apparently, the young spirit is a bit of a recluse. She seems to be bound to the mansion's third floor and shies away from the Hampshire House's private parties. During World War II, the building was acquired by the owners of the Lincolnshire Hotel on Charles Street and turned into a private luxury hotel. In 1969, the town house was purchased by Thomas Kershaw and Jack Veasy, and it is currently the go-to place for elaborate Beacon Hill weddings and catered events. It's no longer a hotel. However, the Hampshire House continues to be a popular gathering spot for intimate celebrations and occasionally opens its doors to the public for special dinner-and-dance parties.

According to one online source, the house's melancholic teen spirit once reached out to the building's staff manager. "One night after closing, when one of the managers was alone on the premises and doing some paperwork, she heard someone calling her name," wrote Adrienne Foster on epinions.com. "When I asked the hostess for more, she had nothing specific to add. She did mention that there had been some speculation the little girl had been murdered."

The late Jim McCabe, former owner of New England Ghost Tours, confirmed the rumors in an interview with *AAA Horizons*. "I had a psychic on a recent tour with me and she believes it was a murder made to look like a suicide."

Foster continued, "When I later talked to McCabe, he said he had a young man on his tour one night who was psychic. As McCabe told the story of the house to his tourists, this young man silently focused on the third floor and saw the image of the girl."

According to Dennis William Hauck's *Haunted Places: The National Directory of Ghostly Abodes*, Judge Thayer was rumored to have had "an improper relationship with his twin daughters," and that traumatic suicide (or possibly murder) would explain why the young girl's residual spirit continues to stick around the Beacon Street mansion. Apparently, the teen apparition occasionally ventures outside of her third-floor comfort zone. "Her ghost has been seen peering over the banisters and out of first-floor windows," concluded Hauck.

File under: Thayer twin

LIBERTY HOTEL

Has the former home of the Hub's "most wanted" become Boston's most haunted? The Liberty Hotel—formerly the Charles Street Jail, which housed a rogues' gallery of old clientele, including several mob

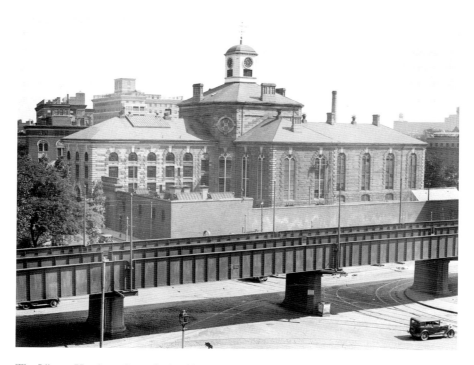

The Liberty Hotel was formerly the Charles Street Jail—which housed a rogues' gallery of old clientele, including several mob bosses—and was the home of the Hub's "most wanted." Has it become Boston's most haunted? *Courtesy of the Boston Public Library, Print Department.*

bosses; a German U-boat captain who killed himself with shards from his sunglasses soon after being captured in 1945; Frank Abagnale Jr., the notorious con artist played by Leonardo DiCaprio in the flick *Catch Me If You Can*; and Boston mayor James Michael Curley, who served time for fraud in 1904—was reborn as a luxury hotel in 2007. However, have the ghosts from the jail's dodgy past left the massive gray granite and brick structure since closing its doors in 1990?

Some guests aren't convinced. "When I told my husband about this place, he looked at me like I was nuts. I don't know if we'll ever actually stay at The Liberty as it has to be haunted and I'm a big chicken," wrote Paloma Contrera from *High Gloss Magazine*. "One hundred fifty plus years of poor living conditions for angry criminals…that is a sure-fire recipe for mean ghosts."

When the jail opened in 1851, it was praised as a world-class model for prison architecture. Built in the shape of a cross, the Charles Street Jail had a

In an attempt to rid the building of any negative residual energy haunting the Liberty Hotel, 215 Charles Street, management brought in a team of Buddhist monks to perform a cleansing ritual. *Photo by Ryan Miner.*

ninety-foot-high central rotunda and four wings of cells. In the late 1880s, each of the 220 rooms housed one inmate. However, things changed as the jail aged and fell into disrepair. In the 1970s, a riot broke out, and inmates sued over the building's squalid, overcrowded conditions. A federal judge ordered the structure closed in 1973, but it took seventeen years for many of the prisoners to find new homes. After a five-year, $150 million renovation, the former lockup reopened as the Liberty Hotel, which tipped its hat to the building's captivating but dark past with a restaurant called Clink and a bar named Alibi. However, only 18 of the hotel's 298 rooms are housed in the building's original jail.

In an attempt to rid the building of any negative residual energy haunting the hotel, management brought in a team of Buddhist monks to perform a cleansing ritual. "Clearly, there are some very dark and depressing elements to this building and we have to be careful how we tell its story," said Stuart Meyerson, former general manager, in the British newspaper *The Independent.* "I don't think everyone enjoyed staying here."

Former Liberty Hotel patron Charlene Swauger of Albuquerque believed the cleansing ritual worked. "I didn't discover any ghosts or anything," she told the Associated Press. "I thought it was very clever."

As far as lingering spirits, the Liberty's marketing manager, Nicole Gagnon, insisted that there are no shadow figures walking the iron railing balconies, which were once catwalks where guards stood watch over the inmates. "Believe it or not, there have been no unusual occurrences here at the hotel," she told me.

However, ghost tour buses passing by the 150-year-old structure allude to the Liberty's spirited past, including a mention that the hotel's courtyard was formerly a gallows, and travel journalists play with the Charles Street Jail's creepy vibe. "The Liberty Hotel, Boston's reconfigured former jail, once housed characters like the Boston Strangler," mused the *Austin American-Statesman* in an article called "Boston's Scariest Haunts" in October 2010. "Guests say they gather in the lobby champagne bar just because there's always safety in numbers."

File under: most haunted?

OMNI PARKER HOUSE

An inexplicable supernatural energy emanates from the oldest continuously run hotel in the country, the Omni Parker House. Besides being one of the more breathtakingly ornate structures in Boston, it's also allegedly one of its most haunted. Originally built in October 1855, the Parker House boasts a slew of ghostly reports ranging from Harvey Parker himself—who passed away on May 31, 1884, at the age of seventy-nine and apparently continues to roam the halls of the hotel he built—to mysterious orbs floating down the tenth-floor corridor and a malevolent male spirit with a disturbing laugh who reportedly lingers in the now off-limits room 303.

Parker's rags-to-riches story started in 1826, when he moved to Boston with nothing but a pocket full of change. He saved his nickels and dimes while working as a coachman for a Brahmin socialite and built a restaurant that later became his namesake hotel. Torn down, except for one wing, and rebuilt in its present gilded glory in the late 1920s, the hotel was called the Parker House until the 1990s, when the Omni hotel chain purchased the Victorian structure. The hotel has several claims to fame, including being the birthplace of the Boston cream pie. It also had a few famous employees, including Ho Chi Minh, who was a busboy, and Malcolm X, who worked as a waiter. John Wilkes Booth stayed at the Parker House eight days before assassinating President Lincoln on April 14, 1865. In fact, he used a shooting

The Omni Parker House's ornate elevators are known to mysteriously stop on the third floor, which was frequented by both Charles Dickens and Henry Wadsworth Longfellow, without anyone pushing a button. There's also the story of room 303, which in 1949 was the scene of a rumored suicide of a liquor salesman who killed himself with barbiturates and whiskey. *Photo by Ryan Miner.*

gallery not far from the hotel to practice his aim before heading to Ford's Theatre in Washington, D.C.

However, the Omni Parker House's reputation as Boston's "most haunted" sometimes surpasses its historical significance. "I first heard about the ghost of Harvey Parker when I began working here in 1941," explained longtime bellman John Brehm in an interview with the *Boston Globe* in 1992. One guest, an elderly woman staying in room 1078, said she saw an apparition of a man outside her room during her stay in the 1950s. "At first it was a misty apparition in the air, then it turned toward her," Brehm explained. "She said it was a heavy-set older man with a black mustache. He just looked at her, then faded away. She came downstairs, a bit jittery, and security went up to the tenth floor. They checked it out, but reported they could find nothing."

Guests continue to report seeing a proper nineteenth-century gentleman with a beard perched at the end of their beds, asking, "I've come to check on your accommodations. Do you have everything you require?" Visitors, convinced that they've seen a ghost, are shown an eerie painting of Parker that resides in the restaurant, and they identify him as the see-through man they spotted at the edge of their beds. Oddly, Parker's apparition is mainly seen on the tenth floor, which didn't exist when he owned the hotel.

"My theory is that when one person works so hard to build an empire, whether it's a city, a business or the [Omni Parker Hotel], they can still be around trying to check on what's going on and how those who are still there are running the place," said Adam Berry from *Ghost Hunters* in an interview with me. "I absolutely believe that Boston has tons of spirits because it was the center of everything. People were building empires, and the more energy that surrounds that kind of situation the more likely there will be spirits lingering about."

While the building's revolving doors greeted presidents, celebrities and ghosts for more than 150 years, the corner of Tremont and School Streets has been a source of darkness for three centuries. "The psychic imprint of the horror known as the Boston Massacre may have caused what parapsychologists call an aura of disaster—fertile ground for the birthing of ghosts," wrote Holly Nadler in *Ghosts of Boston Town*. In 1704, before the nearby massacre that rocked the city on March 5, 1770, five kids sledding down the street next to the former site of the Boston Latin School were killed by redcoats after causing a ruckus with the British constabulary and heaving rocks at authorities.

Incidentally, the School Street entrance to the Parker House is known as one of the coldest spots in the city. "But the cold spots aren't limited to

the hotel's main entrance," wrote Joe O'Shea in *AAA Horizons*. "Inside the venerable Boston landmark, spooks haunt several floors."

For years, guests have reported hearing strange noises such as voices and footsteps coming from empty rooms. Lights mysteriously turn on and off. Doors open and close themselves. Several employees have fled the hotel after having a close encounter with an apparition. "Longtime staffer Ed Cotto has heard reports of large, nebulous white lights on the ninth and tenth floors, and on other occasions he says hotel workers have noted unexplained thumps and grinding noises," wrote Nadler.

Haunted Boston's Jeffrey Doucette said he's heard several ghost stories while swilling a post-tour Scotch at Parker's Bar. "There was a night in October and I came into the bar before a tour. A woman, who was in her mid-fifties and working the bar, asked if I gave the haunted tour and then told me the creepiest story," he recalled. The bartender told Doucette that the hotel's paranormal activity isn't limited to the structure's upper floors. In fact, she watched one disgruntled patron try to leave the building without paying and she witnessed, in awe, as the doormat outside the hotel's School Street entrance flew up and blocked his exit as he tried to flee the Omni Parker House. Obviously creeped out, the man immediately turned around and paid his bill.

Other haunted happenings involved elevators mysteriously being called to the third floor—once frequented by both Charles Dickens and Henry Wadsworth Longfellow. The hotel's ornate lifts are known to mysteriously stop on the floor without anyone pushing a button. There's also the story of room 303, which in 1949 was the scene of a rumored suicide of a liquor salesman who killed himself with barbiturates and whiskey. "More than twenty hotel employees have reported walking into the room and seeing the specter of a naked man lying on the floor," reported the *Boston Globe* in 1999. "The image faded, but the scent of whiskey hung in the air." According to lore, the room—which is now a storage closet—is said to have inspired horror legend Stephen King when he wrote the short-story-turned-film "1408."

On the mezzanine level of the hotel, next to the pressroom where John F. Kennedy announced his candidacy for president, is the so-called "enchanted mirror," which was taken from the *A Christmas Carol* author's room and is known to do odd things when guests say "Charles Dickens" three times. "This mirror is the one that Charles Dickens used to practice his orations in front of," said former ghost tour legend Jim McCabe in an interview. "Not long ago, a worker began to clean the mirror, and he kept

There have been reports of condensation mysteriously appearing on the Omni Parker House's famed "enchanted mirror," located on the hotel's second-floor mezzanine. According to lore, the antique was taken from Charles Dickens's room, and he apparently stood in front of it to practice his nineteenth-century orations. *Photo by Ryan Miner.*

seeing condensation appear on the glass right next to him, as if someone was breathing on it. He hasn't cleaned the glass since."

Staff members and guests continue to report seeing ominous shadows on the walls and fixtures turning on and off by themselves. "But what do you expect in a place that has hosted, for 150 years, thousands of famous celebrities and historic visitors?" mused Cheri Revai in *Haunted Massachusetts*. "It only adds to the atmosphere of authenticity—rubbing shoulders with the rich and famous of the past in a posh, genuine Victorian hotel."

File under: Parker's poltergeists

LANDMARK HAUNTS

B oston is a hotbed of paranormal activity. Whether you're a believer or not, there are more than a few skeletons in the city's collective closet. Many of those three-hundred-year-old secrets can be found in the buildings and landmarks scattered throughout the historic city. In fact, many of the spirits allegedly lingering in Boston might be a byproduct of the strong-willed New England desire to maintain the old buildings of the past, which act as lures to both visitors and ghosts. "Spirits are attracted to the places they lived in," opined the late Jim McCabe, who was a noted ghost lore expert in Boston. "I think what attracts ghosts up here is that you don't tear down the buildings."

Adam Berry echoed McCabe's theory. "Because of the history, there are so many interesting places that could be investigated. It was one of the biggest seaports in the country and had tons of activity during the Revolutionary and Civil Wars. There must be spirits left behind, mulling about and checking out the status of the community they built way back when." During his four-year collegiate stint in Boston, the famed paranormal investigator said he fell in love with the Hub. "Boston's rich history and the singular fact that it was the cornerstone of the American Revolution makes it a city that is truly one of a kind," Berry said. "Why would anyone want to leave...even after they're dead?"

Some skeletons emerged when visitors least expected it. In January 2009, a tourist fell into an unmarked crypt at the Granary Burial Ground during a self-guided tour and got up close and personal with one of the cemetery's

Many of the spirits allegedly lingering in Boston might be byproducts of the strong-willed New England desire to maintain the old buildings of the past, which act as lures to both visitors and ghosts. King's Chapel Burying Ground was the scene of several historical tales from the crypt, including reports of a man who was rumored to be buried alive in 1820. *Courtesy of the Boston Public Library, Print Department.*

tombs, which measures eight by twelve feet in size and is believed to be the grave of an eighteenth-century selectman, Jonathan Armitage. The visitor wasn't hurt, nor did he fall into the actual crypt; instead, it was the stairway leading to the vault.

In 2007, a mysterious sinkhole emerged at King's Chapel Burial Ground, a 250-year-old cemetery dating back to 1757 near Government Center and across from the haunted Omni Parker House. "Beneath the crumbling earth are stairs leading down to the family crypt," reported the *Boston Herald* in January 2007. "It's unclear why this grave in particular is giving way, though time and weather are chief among the suspected causes." The sinkhole, which was blocked off from pedestrians with a black steel cage, continued to baffle the burial ground's conservators for years.

King's Chapel Burying Ground was the scene of several historical tales from the crypt, including reports of a man who was rumored to be buried alive in 1820. One elderly woman strongly believed that a nineteenth-century property owner was buried six feet under by his family in an attempt to get possession of his wealth. An angry mob gathered around the burial ground, demanding that authorities exhume the body. Doctors investigated, and it was announced that he was dead as a doornail. However, the woman continued to believe that the death occurred as the result of his being buried alive.

In 1775, the lauded editor of the *Columbian Centinel*, Benjamin Russell, had an encounter with the supernatural when the historic cemetery on the corner of Tremont and School Streets was known as Stone Chapel. "It was part of my duty as an assistant in the domestic affairs of the family to have the care of the cow. One evening, after it was quite dark, I was driving the cow to her pasturage—the Common. Passing by the burial-ground, adjoining the Stone Chapel, I saw several lights that appeared to be springing from the earth, among the graves, and immediately sinking again to the ground. To my young imagination, they could be nothing but ghosts," Russell recounted in *The Pilgrims of Boston* by Thomas Bridgman.

Russell continued: "I left the cow to find her way to the Common, and ran home at my utmost speed. Having told my father the cause of my fright, he took me to the spot where the supposed ghosts were still leaping and playing their pranks. When, lo! there was the sexton, throwing out as he was digging fragments of decayed coffins. The phosphorus in the decayed wood blending with the peculiar state of the atmosphere, presented the appearance that had completely unstrung my nerves, and terrified me beyond description. I was never afterwards troubled with the fear of ghosts."

Spirits at King's Chapel? It's possible. "There are some who opine that every Boston landmark is haunted," wrote Holly Nadler in *Ghosts of Boston Town*. While Russell had a scientific explanation disproving his childhood ghost story, others believe that Boston has been the epicenter of supernatural activity since the Puritans set foot on the hallowed ground in the early 1600s.

Boston Athenaeum

Boston's haunted library? Nathaniel Hawthorne, author of the classics *The Scarlet Letter* and *The House of the Seven Gables*, claimed that he had a close encounter with a spirit while hanging out at the Boston Athenaeum, a members-only research facility considered to be the nation's oldest library, founded in 1807. It was a private gentleman's club, hosting luminaries such as Henry Wadsworth Longfellow, Henry David Thoreau and, of course, Hawthorne, who read books and shared ideas.

According to his published account called *The Ghost of Doctor Harris*, the famed writer in residence was eating breakfast one morning in 1842 at the library's former Pearl Street location when he noticed a familiar face reading the *Boston Post*. It was Dr. Thaddeus Mason Harris, a well-known Unitarian

Nathaniel Hawthorne, author of the classics *The Scarlet Letter* and *The House of the Seven Gables*, claimed that he had a close encounter with the spirit of Dr. Thaddeus Mason Harris while hanging out at the Boston Athenaeum. The ghost has reportedly moved to the library's posh 10½ Beacon Street location across from the Massachusetts State House. *Photo by Ryan Miner.*

clergyman from Dorchester, sitting in his usual chair in front of the library's second-floor fireplace. Hawthorne didn't bother the old patriarch. However, he was shocked to learn that the Athenaeum regular had passed away.

"That very evening," Hawthorne recalled, "a friend said to me, 'Did you hear the old Doctor Harris is dead?'"

"'No,' said I, very quietly, 'and it cannot be true for I saw him at the Athenaeum today.'"

"'You must be mistaken,' rejoined my friend. 'He is certainly dead!' and confirmed the fact with such special circumstances that I could no longer doubt it."

Hawthorne returned to the Athenaeum the following day and noticed, completely in shock, Harris sitting at his usual spot and reading the newspaper. Yep, Hawthorne spotted the deceased doctor, looking "gaseous and vapory," and he was completely dumbfounded. "His own death must have been recorded, that very morning, in that very newspaper," he continued. "To the best of my recollection, I never observed the old gentleman either enter the reading room or depart from it, or move from his chair, or lay down the newspaper, or exchange a look with any person in the company, unless it were myself," he described.

According to lore, Hawthorne spotted Harris's ghost for six weeks, and he later told his editor that he wished he had confronted the apparition. He wanted to ask him, "So, what's it like to be dead?" or at least find out if the old man knew he had passed. In fact, Hawthorne joked with his editor about the Harris encounter, saying that "perhaps he finally got to his obituary and realized he was dead."

The oddity? When the library moved to its current posh 10½ Beacon Street location across from the Massachusetts State House in 1847, Harris's ghost reportedly followed the Athenaeum's antiquarian books and his own nineteenth-century portrait. In fact, Harris's misty apparition has been spotted waiting to take the elevator to the structure's third floor.

"Most people believe this to be the ghost of the reverend that Hawthorne saw many years ago," remarked Christopher Forest in *Boston's Haunted History*. "The library was moved from that Pearl Street location to the present-day location near the Boston Common decades ago. However, it would appear that didn't stop the dear Reverend Harris from following the books and moving to the new library. Many people think Harris still rides an elevator to the third floor, so many years after he last visited the old building."

The Boston Athenaeum now opens its red door for the public in guided tours. However, the so-called haunted elevator is off limits to visitors, wrote *Ghosts of Boston Town* author Holly Nadler.

"The public is barred from using the haunted elevator, which rises and falls of its own accord as if prankish spirits amuse themselves by flitting in and out of the cabin, pushing buttons for all five floors," Nadler mused. "According to Boston ghost hunter Jim McCabe, thousands of

dollars have been poured into fixing the elevator's unending glitches, to no avail."

In 2002, the Athenaeum bought a brand-new elevator—and it's still acting up. Recent visitors who toured the library contend that the lift still has a mind of its own.

File under: library lore

CHRIST CHURCH

The second-oldest church in Cambridge, with a history spanning more than 250 years, Christ Church located at Zero Garden Street is rumored to be haunted by a British soldier who occasionally reveals himself and blows out candles. *Courtesy of the Boston Public Library, Print Department.*

Wanna hobnob with the ghosts of Cambridge's historic past? Built in 1759, Christ Church has hosted a slew of the country's luminaries, ranging from George and Martha Washington, who rallied to save the building from neglect, to Teddy Roosevelt, who taught Sunday school while studying at Harvard. In 1968, Martin Luther King Jr. and Dr. Benjamin Spock held a press conference in the structure's Parish Hall and formally announced their support for the antiwar movement and their opposition to the Vietnam War.

The second-oldest church in Cambridge, with a history spanning more than 250 years, Christ Church is rumored to be haunted by a British soldier. "He was buried under the church after being thrown from a wagon," reported *Cambridge Day* in 2005. "The church was considered Tory,

sympathetic to the British cause during the American Revolution, and the ghost wanders the pews looking for his regiment."

Many of the church's founders lived on Tory Row, now called Brattle Street. Christ Church's initial mission was "to minister to English families in Cambridge and students at Harvard." The British rented out box pews at the Anglican church, and as the Revolutionary War waged on, the chapel was closed until 1790. It was renovated in 1883 and then restored to its original design in 1920. The Harvard Square church, located at Zero Garden Street, is a Cambridge anachronism, looking as it did during the mid-eighteenth century. Incidentally, it was attacked by angry Patriots because of its Tory leanings, and the church's organ was melted and turned into bullets during the war.

The ghost story centers on the Battle of Saratoga in 1777, when Christ Church was reopened for the internment of English and German prisoners known as the Convention Troops. Apparently, neither the locals nor the administration at Harvard College wanted anything to do with the imprisoned British redcoats. However, hundreds of foreign soldiers wandered the streets of Cambridge and were imprisoned later as the war blazed on in New England.

In June 1778, a British redcoat known as Lieutenant Richard Brown lost control of his horse-drawn carriage while descending Prospect Hill in Somerville. According to E. Ashley Rooney's *Cambridge, Massachusetts: Ghosts, Legends & Lore*, Brown was stopped by an American sentry, who pulled out his gun at the frazzled soldier. Brown pointed to his sword, which indicated his rank and privilege. The sentry shot Brown in the head, and he was buried on June 19, 1778, at the only church in town where Americans and British worshiped together. He was interred with military honors in the Vassal tomb vault many feet beneath the church.

The spirit haunting Christ Church is rumored to be Brown. "The ghost of British Lieutenant Richard Brown is thought to still walk about the sanctuary," wrote Rooney. "Visitors may see that the candles are suddenly extinguished and hear odd shuffling noises and doors bang—yet no one is there."

Former church archivist Donna LaRue, in the October 31, 1986 edition of the *Harvard Crimson*, echoed the ghostly rumors. "He comes up once in a while and blows out candles," she said.

File under: holy ghost

KING'S CHAPEL BURYING GROUND

King's Chapel Burying Ground boasts a few ghostly legends of its own, including a strange story of roaming spirits looking for their markers and an unmarked gravestone believed to be the final resting place of the infamous pirate Captain Kidd. *Photo by Ryan Miner.*

While most ghost lore experts name Boston Common's Central Burying Ground as the most haunted cemetery in the Hub, the older King's Chapel Burying Ground—built in 1630 and hosting a slew of Puritan founders, including Governor John Winthrop, Reverend John Cotton and Mary Chilton (the first woman to walk off the *Mayflower*)—boasts a few ghostly legends of its own. Included in these is the strange story of roaming spirits looking for their markers. In 1810, there was a switcheroo of sorts when the superintendent of burials moved most of the headstones at the cemetery and laid them out in neat rows closer to the center of the yard. The legend states that the moving of the headstones confused the spirits so much that ever since they've wandered looking for their graves.

Incidentally, the cemetery is built adjacent to King's Chapel, an Anglican church. Many of the big-name burials were Puritan elders who left England in search of religious freedom. Ironically, their final resting place is next to the church they fled.

In addition to the wandering-ghost myth, a macabre story associated with the churchyard states that a woman is buried there whose head was cut off and placed between her legs. The story goes that the carpenter built the woman's coffin too small and, in an attempt to cover his blunder, decapitated the corpse, placed the head inside the coffin and nailed the lid shut. No proof exists as to the legend's truth.

Another story associated with the churchyard centers on an unmarked grave at the rear of the cemetery. Although the gravestone has no name, many believe it's the final resting place of the infamous pirate Captain Kidd. While the salty dog was definitely arrested in Boston in 1701 and was hanged and buried in the city, little proof exists to either support or disprove the idea

that he was interred next to King's Chapel. Of course, it doesn't stop the pirate-themed ghost stories. "There are some grave-goers who swear that Kidd's spirit can be summoned late at night, during the bewitching hour, and seen patrolling Boston's ancient burying ground," wrote Christopher Forest in *Boston's Haunted History*. "Legend has it that Kidd is the most restless of the historic burial ground's denizens," added Joseph Mont and Marcia Weaver in *Ghosts of Boston*. "Should the gate be left open at its Tremont Street entrance, visitors are ill advised to trespass after dark."

In addition to the mischievous pirate spirit, many visitors claimed to have problems with their cameras and recording devices when visiting the site. Some have noticed that their video footage was mysteriously deleted and batteries drained while walking in the cemetery. After leaving the so-called energy vortex, their electronic devices returned to normal.

Why does so much ghost lore surround the old-school burial ground? "People are fascinated with cemeteries," explained Jim McCabe in a 2007 interview with the *Boston Herald*. "It's like going to a historical house. King's Chapel offers the very, very old amongst a twenty-first-century city. The rest of the country just doesn't have the sense of history we do."

Adam Berry from *Ghost Hunters* believes that "the older the cemetery, the more intimidating." King's Chapel, dating back to the early 1600s, is no exception to the rule. In fact, Berry said that it's highly plausible that the cemetery has residual energy simply because it's been around for centuries.

But is King's Chapel Burying Ground haunted? Perhaps. Berry believes that some spirits return to their graves, even after passing almost three centuries ago. "Cemeteries are where they go to rest and don't want to be bothered. I don't believe they're bound or held captive in that specific spot. However, I do feel they're abundant."

File under: cemetery spooks

Old Powder House

The ominous stone tower overlooking the six-way intersection at Somerville's Nathan Tufts Park was initially built as a windmill by John Mallet in 1703 and then transformed into a powder magazine. In 1774, the British governor, Thomas Gage, confiscated the 250 barrels of gunpowder stored in the round structure so that the ammunition wouldn't be used by the American Patriots during the Revolutionary War. Musket-toting colonists—ticked off by Gage's orders to steal

Resting on a hill a stone's throw from Tufts University, the Old Powder House in Somerville has a colorful and allegedly haunted history that can be traced back to before the Revolutionary War. *Courtesy of the Boston Public Library, Print Department.*

the powder—made their way to Cambridge, ready to fight. According to *Somerville, Past and Present*, an estimated fifty thousand armed men from across the colonies responded to the word-of-mouth alarm.

Resting on a hill a stone's throw from Tufts University, the Old Powder House has a colorful and allegedly haunted history that can be traced back to before the war. Included in this back story are sightings of a cranky old spirit who haunts the mill on windy nights and spews curse words at passersby. In addition to the foul-mouthed apparition, reports suggest that some kind of residual energy of past trauma exists in the form of a phantom ball of blue sparks.

Why is the ghost so angry? According to Charles Skinner in *Myths and Legends of Our Own Land*, the old mill was the site of a tragic love story. Apparently, a penniless Somerville farmer and his girlfriend, the daughter of a wealthy landowner, once used the stone structure as a regular meeting place. One night, the father followed his daughter to her secret love nest. The maiden hid at the top of the mill to avoid her pops. She grabbed a rope to shimmy up the structure and somehow managed to set off the windmill's machinery. Her father's arm was accidentally severed by the grinding millstone. The girl's lover arrived, and they carried her father home. The father's injuries were fatal. However, his spirit is rumored to live on at the Old Powder House.

"Before she could summon heart to fix the wedding day, the girl passed many months of grief and repentance, and for the rest of her life, she avoided the old mill," wrote Skinner. "There was good reason for doing so, people said, for on windy nights, the spirits of the old man used to haunt the

place, using such profanity that it became visible in the form of blue lights, dancing and exploding about the building."

Yep, the old man's ghost was cussing up a blue streak. There's also a contemporary retelling of the ghost story that involved a cross-dressing woman. "One version of the story tells of a young woman, dressed as a man, who sought refuge in the loft one night. But somehow a man who was up to no good discovered that she was actually a woman and tried to molest her," explained Cheri Revai in *Haunted Massachusetts*. "In the process, he became entangled in the mill's machinery and died. His restless spirit is said to still haunt the Powder House today."

Incidentally, the spirit's potty-mouthed antics continue to live on with hotheaded drivers and pedestrians trying to navigate the six-lane rotary in front of the haunted sentinel. In fact, Powderhouse Circle has the claim to fame of having the most motor-vehicle collisions in Somerville based on statistics collected by the city's SomerStat group. Massachusetts drivers? Now that's scary.

File under: blue lights

NIGHTLIFE HAUNTS

Wanna down a couple of frothy brews with Casper the Tipsy Ghost? For the record, he gets a little less "friendly" after slamming a few Pete's Wicked Ales. Whether you're a believer in the "Boo!" business or an amused skeptic, I've assembled a motley crew of nightlife locales that are rumored to be stomping grounds for spirits…and I don't mean the kind that come in a chilled martini glass. Nope, the list includes a bevy of atypical haunts, ranging from a sleek new lounge in the Back Bay to an old-school candlepin alley in Somerville's Davis Square.

Historically, Boston's watering holes were gathering places for Revolution-era Patriots and were, in essence, "nerve centers for spreading vital news and sanctuaries for outlawed organizations," wrote Roxie Zwicker in *Haunted Pubs of New England*. "Certain pubs bore witness to ghastly deeds and sorrowful tragedies," Zwicker continued. "Some of them became tinged with the aura of the supernatural."

In addition to the apparitions mulling about in old-school hangouts like the Union Oyster House, contemporary tragedies have conjured up spirits from Boston's speakeasy past. For example, the Cocoanut Grove nightclub fire in November 1942 sent shock waves throughout the Northeast, resulting in almost five hundred fatalities and inspiring the reform of safety standards and fire codes across the country. Some believe there's an inexplicable energy, or a supernatural imprint, lingering in the area of what has been called the "worst disaster in Boston's history."

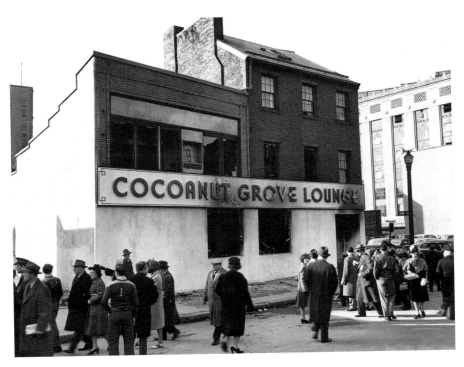

The Cocoanut Grove nightclub fire in November 1942 sent shock waves throughout the Northeast, resulting in almost five hundred fatalities and inspiring the reform of safety standards and fire codes across the country. Some believe there's an inexplicable energy, or a supernatural imprint, lingering in the area of what has been called the "worst disaster in Boston's history." *Courtesy of the Boston Public Library, Print Department.*

Wendy Reardon, who shared her story of supernatural stripping on the Biography Channel's *My Ghost Story* and claimed that her Boylston Street pole-dancing studio, Gypsy Rose, was haunted by multiple ghosts, said her eyes welled up with tears when she visited the Cocoanut Grove site. She felt like there were souls from the 1942 fire still trapped there. "I can't get the image out of my mind of people trapped and writhing in the door," she said. "And why did they just put in a plaque in 1992…fifty years after it happened? It's hallowed ground. Those victims deserve more than just a plaque on the ground that you can walk right over."

Located across the street from another alleged haunted locale, Jacques Cabaret, the Cocoanut Grove site is currently a parking lot. It was believed that a busboy caused the blaze when he lit a match in the Melody Lounge basement, although he was later exonerated. The South Seas–inspired decor inside the nightclub had palm trees made of flammable paper,

and a massive flash-over engulfed the building within minutes. "The difference between life and death was a matter of seconds for many and of moments for more, in a fire that flashed with the flare of a match and had spewed dead bodies into the street within five minutes when the first firemen arrived," reported the *Boston Globe* on November 30, 1942. "The chief loss of life resulted from the screaming, clawing crowds that were wedged in the entrances of the club."

Reardon said she could feel the energy near the Grove's former Piedmont Street entrance. "I went into the parking lot and just stood there…and the sadness," Reardon emoted. "It wasn't only the sadness I felt though, it was shock and surprise…like we were just having a great time, now it's an inferno and now it's burning. More surprise than anything."

Last dance at the Cocoanut Grove? There's at least one believer who's convinced that the party never ended in Boston's Bay Village.

THE BRAHMIN

Is there a well-dressed ghost spooking the staff of The Brahmin? Russ deMariano and Ed Brooks, the duo behind the new restaurant and lounge on Stanhope Street, said that their elaborate summer-long renovation project in 2011 stirred up paranormal activity at the space formerly occupied by 33 Restaurant & Lounge. It started back in July when the two-story building, once a carriage house and stables, was transformed into a brownstone-inspired homage to Boston's early eighteenth-century elite. While working in the kitchen area, Brooks and deMariano were visited by a shadowy figure.

"One night we were closing a gate downstairs to go into the liquor room. And behind that door—the light is always on—we did see something walk by…a shadow…underneath the door," said deMariano. "You know when you do a double take and see something at the corner of your eye? I'm not sure what we saw." When he and Brooks investigated the space, no one was there—and Brooks noticed that the temperature had become extremely chilly. Completely spooked, the two fled the restaurant.

Brooks claimed to be more of a Scully than a Mulder. But he said he's seen shadows moving underneath the door, as if someone were pacing back and forth. His mother, Judy, a self-proclaimed sensitive to the spirit realm, told her once-skeptical son that The Brahmin space had a paranormal presence

The Brahmin, a new restaurant and lounge on Stanhope Street in Boston's Back Bay, is reportedly haunted by a phantom wearing an old-fashioned gray suit. The restaurant's owners have seen shadows moving underneath the door, as if someone were pacing back and forth. *Photo by Ryan Miner.*

from the beginning. Also, deMariano's mother, Susan, who likewise believes in the supernatural, swore she spotted a man dressed in an old-fashioned gray suit who vanished after a second glance.

"Whatever this thing is, it seems that he's into breaking glass," deMariano continued. "One night we heard a large crash, and I thought the chandelier had fallen down the staircase. Ed and I looked in every room twice, and we didn't find anything. A couple of servers have heard glass break, and we thought that someone may have walked up the stairs and ran into someone with a plate of food and it smashed. But there was nothing there."

Tiffany Spearman, lead server at The Brahmin, echoed the owners' accounts of paranormal encounters. "There have been a couple of times, late at night, when I'm checking the women's room and see a reflection [of a figure in the mirror] on the door when it's closed," said Spearman.

Based on the building's history, there may be a residual paranormal energy emanating from what was the scene of "one of the city's nastiest fires," dating back to July 1, 1955. The former Red Coach Grill, located at 41–45 Stanhope Street and literally next door to The Brahmin, was hit by a massive blaze more than fifty years ago that caused $150,000 in damages. According to *Boston's Fire Trail*, twenty-five Boston firefighters were overcome with smoke inhalation and injuries. It was an unusually hot and humid July day, with temperatures expected to reach one hundred degrees.

A trash collector opened the basement door at the two-story building at about 7:30 a.m. and was greeted by a blast of heavy, acrid smoke. Ladder Company 13 rushed to Stanhope Street. The restaurant, which is currently the home of an Asian-inspired eatery called the Red Lantern, only had a few windows, and ventilation was a major issue. Firefighters collapsed at the scene because of the toxic smoke pouring from the restaurant's burning rubber seats. According to *Boston's Fire Trail*, "The engine companies were having trouble getting into the basement," and the narrow stairways to the downstairs area made fighting the fire difficult.

There were no reported fatalities linked to the July 1, 1955 blaze on Stanhope Street. However, paranormal experts like Adam Berry from Syfy's *Ghost Hunters* believe that the residual energy from the early morning fire in the '50s may have left a supernatural imprint. "Anytime there's a traumatic event, it could be left behind," Berry told me in an interview. "If you walk into a room and two people have been arguing, fiercely, you can feel that weirdness that they've created or energy they emit spewing at each other. I do think there's a form of energy that can be left behind from a traumatic event or any kind of murder or suicide

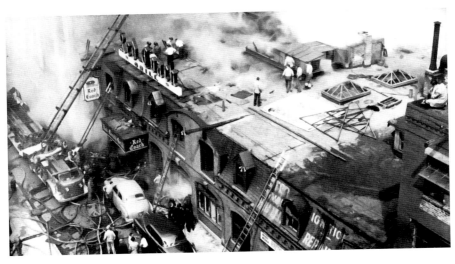

There were no reported fatalities linked to the July 1, 1955 blaze on Stanhope Street. However, paranormal experts believe that the residual energy from the early morning fire in the '50s may have left a supernatural imprint on the buildings surrounding the now-closed Red Coach, including The Brahmin. *Courtesy of William Noonan, Boston Fire Historical Society, www.bostonfirehistory.org.*

in a room. The theory is that maybe that energy goes into the walls and lingers there."

So it's no surprise that deMariano and Brooks heard unidentifiable sounds coming from the basement in July—the Red Coach Grill fire also happened in July—nor is it odd that they heard what sounded like glass breaking in the downstairs area. Firefighters broke windows to ventilate the building.

The co-owners of The Brahmin said they're probably not going to reach out to a paranormal investigation team anytime soon. "I'm not sure if I want to start spooking people and staff," deMariano added. "I'm not seeing any broken glass on the ground. Nothing has been damaged and no one has been hurt, so we're going to leave whatever or whoever it is alone and let them do their thing."

As far as the reports of a man wearing an old-fashioned gray suit? Incidentally, the investigators at the scene of the 1955 blaze wore similar outfits, and the three-alarm fire happened right behind what was the former Boston Police Headquarters. While it's not known if The Brahmin is a postmortem hangout for '50s-era Jakes, there's at least one guest who may not leave after last call.

File under: Stanhope spooks

JACQUES CABARET

Night of the Living Diva sounds like a good title for the campiest zombie flick never made. But here's a real-life equivalent: Boston-based comedian Jim Lauletta said he had a close encounter of the paranormal kind in 2010 while performing a stand-up set at Jacques Cabaret, a Bay Village theatrical space known for its drag shows. Lauletta has appeared everywhere from Comedy Central to HBO, thanks in part to his knack for channeling celebrities in his impressions. But he says he also possesses an uncanny ability to tap into the spirit realm. "I felt a little uneasy when I went down to the basement of the club," Lauletta recalled, saying he felt a "whoosh" feeling when he was walking down the stairs. "I then saw something out of the corner of my eye, looked and it was gone."

Lauletta asked former Jacques performer Ashley Michelle if the nightclub was haunted, mentioning his run-in with the strong energy with "a bit of an attitude" on the stairs. "He told me about Sylvia Sidney, and I then told Ashley about the vibes I got and described her to a tee." Sylvia Sidney, born Sidney Sushman, is a legend in the Boston-area LGBT community. The

Jacques Cabaret, a Bay Village theatrical space known for its drag shows, is located near the site of one of Boston's most tragic disasters, the Cocoanut Grove nightclub fire that killed 492 people in November 1942. The nightclub is rumored to be haunted by a legendary drag queen. *Photo by Ryan Miner.*

late, great trailblazer began his career as a drag performer in 1947 at the age of seventeen and was famous for crossing over into mainstream venues. "I nailed her attitude, what she looked like and even some of the things she would have said without ever meeting her," Lauletta remembered.

Sushman and his crass, drag alter ego, the self-proclaimed "Bitch of Boston," passed away on December 16, 1998. The man behind the makeup was interviewed by The History Project in '96 and asked how he wanted to be remembered. "As a fun-loving, outspoken homosexual who spoke his mind," Sushman shot back. "And, if people didn't like it, the hell with them, my dear. That's the way I've been all my life and I've lived my life accordingly." Apparently, Sidney's legendary attitude carried over into the afterlife.

On top of that, Jacques Cabaret is located near the site of one of Boston's most tragic disasters, the Cocoanut Grove nightclub fire that killed 492 people in November 1942. Historical accounts indicate that the nearby garage of a Bay Village film-distribution company served as a temporary morgue for the hundreds of partiers who were engulfed in flames, some reportedly still holding drinks in their hands. Several of those presumed dead who were dropped off there were actually still alive. And it's rumored that the Jacques building may have been that makeshift morgue. "That totally makes sense," Lauletta said of the Cocoanut Grove connection. "It felt like a very heavy energy in that place when I went down there."

While the rumors tying Jacques Cabaret to the Cocoanut Grove are unsubstantiated, there's no denying the proximity of the building to the former nightclub's Piedmont Street entrance. In fact, the tribute plaque honoring the victims of the tragedy is right across the street from the performance venue, which was opened in 1938 by Henry Vara and catered to drag queens, actors and Theater District producers back in the day. The Grove was a one-story structure that stretched over half a block, without windows. "One whole side, on the Piedmont Street side, is solid wall, cement," reported the November 30, 1942 edition of the *Boston Globe*. Henry Watson, a taxicab driver who helped pull bodies out of the charred building, said the morgue was directly across from the club's revolving doors. "There was a garage across the street," he said. "The police had kicked the door in, and we carried the victims in there." Piedmont Street, including the area next to Jacques, did become a makeshift triage for many of the Grove's casualties. "A line of more than fifty stretchers was formed along Piedmont Street, running up to and around the corner into Broadway," the *Globe* continued.

Haunts of the Hub

Both the Cocoanut Grove fire and Sushman have left an indelible mark on Boston's Bay Village. However, Lauletta was able to find comedic relief despite the talk of tragedy. When asked if he's had any other local ghostly encounters, Lauletta joked, "I know the ghost of my comedy career haunts a couple of buildings on Warrenton Street, but other than that there are none that I'm aware of." He continued, "Actually, Dick's Beantown Comedy Vault gives me a weird vibe. And sometimes when I do my show, there's a light bulb that goes off and on when I'm onstage."

He laughed, "Maybe it's God just giving me the light to get off the stage."

File under: creepy cabaret

SACCO'S BOWL-HAVEN

Are ball-wielding spirits still frolicking at Sacco's Bowl-Haven in Somerville's Davis Square? Back in 2009, crews from the Syfy show *Ghost Hunters* arrived to investigate some strange occurrences—an inexplicable dark shadow, the sound of child-like laughter from the area behind the candlepin alleys and even reports of the ghost of a former worker, Charlie, still lingering in the maintenance room. Such happenings seem fitting for a space that exuded so much history: originally opened in 1939, Sacco's remained a total throwback to the '50s until 2010, when renovations added a wood-fire oven and a sleek bar space, turning the joint into a hipster hangout where locals flock for bowling, brews and the Flatbread Company's pizza concoctions.

During the *Ghost Hunters* investigation, then-co-owner Joseph Sacco claimed that a dark shadow would pass by him at a very high speed. Damon Sacco had similar scares. "My employees seem to think there are some weird things happening after hours," the then-co-owner spilled to the *Ghost Hunters* team. "I definitely heard some funky stuff at night." One guy quit because he felt something, or someone, behind him breathing on his neck.

According to the March 1, 2009 edition of the *Boston Globe*, Joseph Sacco heard "a real definitive footstep" at least four or five times coming from above the lanes when he worked the closing shift. "And then there's the dark shadow," he said, adding that a few times after the lights went off, a "mass would go flashing by me at very high speed."

Dee Morris, coauthor of *Somerville, Massachusetts: A Brief History*, was contacted by the paranormal investigative team. She didn't uncover any

Sacco's Bowl-Haven in Somerville's Davis Square was the site of some paranormal activity, including inexplicable dark shadows, the sound of child-like laughter from the area behind the candlepin alleys and even reports of the ghost of a former worker, Charlie, who was said to haunt the complex's maintenance room. *Photo by Ryan Miner.*

skeletons in Sacco's candlepin closet. However, she told the *Globe* that Davis Square "was very, very active in Revolutionary times," with a redcoat siege occurring on Willow Avenue. She also mentioned that colonial-era Somervillians had a thing for lawn bowling and came up with the possibility that the sounds of pins falling at Sacco's had the potential of conjuring memories of the British ambush. Morris admitted that she may have thrown a gutter ball with the far-fetched theory.

Comedian/historian Jimmy Del Ponte came up with several paranormal scenarios. Perhaps it was the legendary Minnesota Fats, ticked off because a Somerville shark beat the pool player at his game during a heated round at Sacco's billiards area. There are also unsubstantiated reports of a murder at the after-hours nightclub formerly next door.

After the EVP meter was packed away, the show's TAPS team discovered that there were non-supernatural explanations for most of the phenomena—for example, the so-called breathing noise heard by staffers turned out to be a leaky toilet. However, Sacco said that "they did find a few things that were bizarre," like "extraordinarily high levels of electromagnetic energy" in the space, which would explain the ghostly reports from former staff members.

Mike Brooks, assistant manager of the Flatbread Company, says things have changed a lot since the ghost-busters paid a visit: the pool table space was transformed into an open dining area, and there's been much turnover among the site's pre-renovation employees. But one thing hasn't changed. Brooks has heard of a few "creepy encounters" from the current staff, especially when the lights are turned off after closing.

File under: spirit bowling

Union Oyster House

History oozes from the wood-paneled walls of the oldest continuously operated restaurant in the United States, the Union Oyster House, which originally opened in 1826. Before serving bivalves by the dozen and tall tumblers of brandy to nineteenth-century luminaries like Senator Daniel Webster, who came to the restaurant's U-shaped mahogany oyster bar almost daily, it was an eighteenth-century dry goods store and home to Isaiah Thomas's *Massachusetts Spy*, an anti-British tabloid that mobilized the rebellious Patriots in the years leading up to the Revolutionary War. Louis Philippe, former king of France who was in exile after the revolution in his

Union Oyster House, which originally opened in 1826, hosted many famous politicos, including President John F. Kennedy and Daniel Webster, who notoriously devoured six plates of oysters while tossing back a tumbler of brandy almost daily. Workers report feeling "a presence" or an odd energy emanating from the downstairs area. *Photo by Ryan Miner.*

country, rented out the upstairs quarters in 1797, using the fake name of Duc de Chartres and giving French lessons to young women.

The Georgian-style structure located at 41–43 Union Street is so old that the original building, dating back to 1714 and erected a quarter of a century before Faneuil Hall, was waterfront property overlooking the Boston Harbor. Fishermen would maneuver their boats within a few feet of the oyster bar to deliver their catch of the day. America's first female server, Rose Carey, worked there in the early 1920s, and there's a photo of the waitress on the stairwell wall. Owners of the restaurant introduced the toothpick to America in 1890, getting the idea from the natives in South America. President John F. Kennedy, when he was senator and congressman, would dine on the second floor of the Union Oyster House, reading the Sunday newspaper and eating

lobster soup. There's a gold plaque bearing his likeness and honoring the former president at table eighteen, his favorite booth.

The structure was threatened in 1951 when a three-alarm fire swept through the second floor of the oyster house. Three firemen were injured, but the original raw bar and booths were unharmed. Some say the blaze stirred up spirits that had remained dormant for years.

In addition to its historical pedigree, which included kings, presidents and even actors like Matt Damon and Meryl Streep, the Union Oyster House has a long-standing reservation for a few of the building's resident spirits. There are far-fetched accounts of President Kennedy's ghost making a return visit to his Sunday haunt. "The Kennedy family was known to be quite fond of the oyster house and JFK even has a booth dedicated to him," reported an online site, adding that patrons claimed to have spotted "Kennedy's apparition wandering near his booth."

Also, many believe that Daniel Webster, who notoriously devoured six plates of oysters while tossing back a tumbler of brandy almost daily, still holds court at the U-shaped oyster bar that bears his name. "Visitors to the Union Oyster House come not so much for the food as for the thrill of eating the same dish in the same spot as some of America's historical figures," mused an online restaurant site, alluding to former presidents like Calvin Coolidge, Franklin D. Roosevelt and Bill Clinton who have dined there when they visited Boston. "You can claim a stool at the raw bar and slurp oysters next to the ghost of Senator Daniel Webster, a regular who daily enjoyed his tumblers of brandy with oysters on the half shell." For the record, Webster became a Massachusetts senator in 1827, one year after the restaurant opened as the Atwood & Bacon Oyster House.

Bob Eshback, a veteran shucker and bartender at Webster's namesake hangout, told me that he and other employees have experienced paranormal activity in the Union Oyster House's basement. Contrary to the ghostly rumors, the late nineteenth-century senator reportedly left the building years ago, and JFK hasn't made a postmortem comeback. When asked where Webster sat in the 1800s, Eshback said it was standing room only for the restaurant's most revered patron. "He didn't sit, he stood," Eshback responded. "There were no stools back then."

While Eshback claimed to be more of a skeptic than a believer, he said that he felt "a presence" or an odd energy emanating from the downstairs area when he starting working for the restaurant in 1999. "There are reports of a busboy or a dishwasher committing suicide in the basement in the early twentieth century or possibly the late nineteenth century," Eshback

explained, adding that he hasn't felt the ghostly energy in the past five years or so, but he avoided the storage area below when he first tended bar in the late '90s. "Many people who have worked here didn't like going down there because of the presence."

File under: Union spirits

THEATER HAUNTS

The show must go on—even in the afterlife. Talk to anyone who has worked backstage at a theatrical venue, and they'll have a ghost story or two of a close encounter with a playhouse phantom. For some reason, spirits love live theater. Armed with dozens of refurbished, historic performance structures scattered throughout the city, Boston is no exception to the "house ghost" rule. "The hard part isn't finding theaters that are haunted—it's finding theaters that aren't," joked Tom Ogden, author of *Haunted Theaters*.

Skeptics contend that the inexplicable noises often reported in sites such as Boston University's Huntington Theatre can be attributed to acoustics. However, the mischievous spirits at Emerson's Cutler Majestic will shut down the soundboard at the renovated theater when they're not happy with a show. Boston's undead critics sure can be picky.

Why haunted theaters? Holly Nadler, author of *Ghosts of Boston Town*, believes it's the romantic aesthetic. "All old and beautiful theaters look haunted, with their shadowy corridors, flickering lanterns, vaulted ceilings, and Gothic ornaments," she wrote. "They also sound haunted, from the creaking of woodwork, the rustling of old pipes, the sighs of air currents trapped inside thick stone walls. And indeed, there are some who contend that all old and beautiful theaters really are haunted."

One of America's more notorious haunted venues is the renovated Ford's Theatre in Washington, D.C., where John Wilkes Booth assassinated President Abraham Lincoln on April 14, 1865. According to reports, a

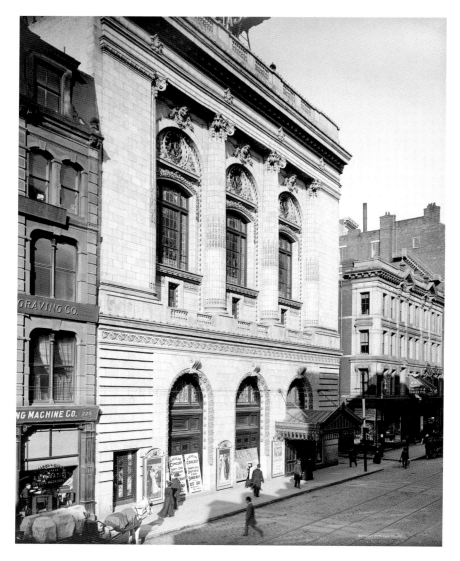

The mischievous spirits at Emerson's Cutler Majestic, 219 Tremont Street in Boston's Theatre District, will shut down the soundboard at the renovated theater when they're not happy with a show. Boston's undead critics sure can be picky. *Courtesy of the Boston Public Library, Print Department.*

psychic imprint of the murder remains, with witnesses allegedly hearing footsteps rushing toward the box where Lincoln sat that fateful night with his wife, soon followed by a gunshot and screams. Cries of "He has killed the president!" and "Murder!" have reportedly echoed throughout the theater.

Actors claimed that there's an inexplicable icy presence on a specific part of the stage. Also, there have been sightings of a shadow figure scurrying across the venue that has been associated with Booth's nineteenth-century getaway.

"For over a century the abandoned Ford's Theatre stood as a hulking ruin and a monument to one of our nation's great tragedies," Nadler penned. "Then, in 1968, the building was refurbished as a museum and working playhouse and a strong occult presence has made itself known there ever since. Curtains rise and fall by themselves, lights go on and off without human supervision. Footsteps echo in empty halls, and the disembodied voices, laughter, and sobs erupt from all sides of the house."

Of course, Booth has ties to one of Boston's most haunted hotels, the Omni Parker House, where he stayed for eight days before assassinating the president. The well-respected actor turned assassin even used a shooting gallery not far from the hotel to practice his aim before heading to Washington, D.C. And to think that only a few years before, he was on stage at the former Boston Museum theater playing to a sold-out audience in Shakespeare's *Romeo and Juliet*.

Yes, all the world's a stage...and all of the lingering spirits are merely players.

Boston University's Huntington Theatre

It's been almost a century since actor Henry Jewett made his last curtain call at the Repertory Theatre, the playhouse he established in 1923. Since that time, the venue has become known as the Huntington Theatre. Jewett, who built the playhouse when motion pictures started gaining popularity, died a few months after his acting troupe disbanded and succumbed to financial ruin in 1930. While the Australian-born transplant's final days played out like a Shakespearean tragedy, his spirit reportedly lives on at Boston University's Huntington Theatre.

"The story goes that he committed suicide underneath the stage, where the trapdoor currently is," said the theater's Lisa McColgan in a March 2008 interview with the *Boston Herald*. "He may not be the only one here. With a building this old, especially a theater, you've got a huge backlog of energy."

According to reports, workers have spotted a larger-than-life gentleman lounging in the back row during tech rehearsals, and electrical equipment has mysteriously shut on and off with no scientific explanation. "He makes the lights flicker or the phone ring," said the Huntington's press rep when

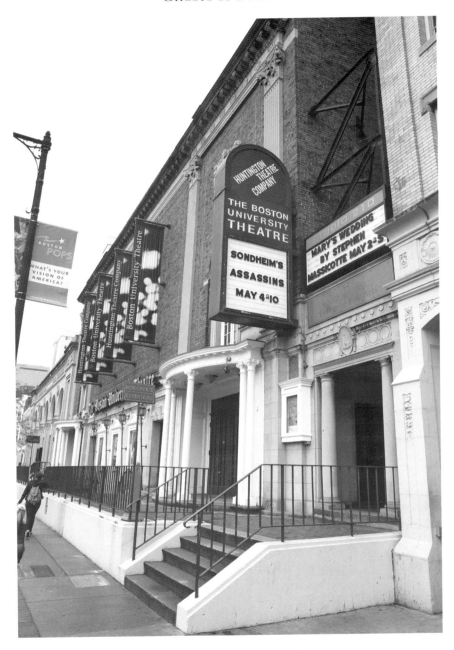

Boston University's Huntington Theatre is rumored to be haunted by several ghosts, including the playhouse's former owner and a now-passed wardrobe mistress. Workers have spotted a larger-than-life gentleman lounging in the back row during tech rehearsals, and electrical equipment has mysteriously shut on and off with no scientific explanation. *Photo by Ryan Miner.*

asked about Jewett's lingering spirit. In addition to the theater's spooky ambiance, there's a portrait of Jewett dressed as Shakespeare's Macbeth in the Huntington's lobby. The role, which oddly mimics Jewett's ambitious rise and dramatic fall within Boston's theater scene, is believed to be cursed. In fact, many superstitious theater workers refuse to utter the M-word, calling it "the Scottish play."

"I firmly believe in theater ghosts, and I respect other people's superstitions," mused actor Terry Caza in an interview with the *Boston Globe* while performing at the Huntington in 1996. "We work in a place where magic and alchemy are created on a regular basis."

Jewett's ghost, affectionately called "Hank" by Huntington staffers, isn't the only supernatural entity rumored to haunt the theater, which was purchased by Boston University in 1953. An apparition known as the Lady in White, who is believed to be a former wardrobe mistress, has been spotted hovering around during dress rehearsals. In addition to the apparition sighting, a Huntington staffer heard a female voice whisper, "I don't like it in the dark" in the theater's lounge. Shadow figures have been seen on the catwalks above the stage and in the building's storage rooms. There's an area called the "willies spot" in the lower lobby where a former box office manager reported feeling a cold presence pass through her.

Many actors who perform at the Huntington talk about a grainy, black apparition called The Sentry, believed to be a protective guardian spirit and often seen outside the green room. "The popular belief is that The Sentry patrols the halls as a one-man security force, and after a person's nervous first exposure to him, he is accepted as a sign that all is safe and sound inside the theater," wrote Holly Nadler in *Ghosts of Boston Town*. "Because of The Sentry's protective quality, he's generally taken to be the ghost of the Huntington's founder."

When a TV crew tried to shoot some footage at the Huntington in the mid-'80s for a show about haunted theaters, the group was mysteriously locked out after an unseen entity slammed the door shut. The Sentry was blamed for the lockout. "I think he was just messing with them," joked McColgan. "You don't feel it's ever malevolent. If anything, it's almost reassuring. You just definitely get the sense that there's somebody else in the theater with you."

Incidentally, Jewett didn't commit suicide at the theater, contrary to the eighty-year-old legend. According to the June 25, 1930 edition of the *New York Times*, "Henry Jewett, actor, died at his home, The Branches, early today. He was 68 years old." While the report doesn't specify how Jewett passed, he didn't end his life under the stage of the 850-seat theater.

However, the playhouse he built for the Henry Jewett Players acting troupe did eventually fall prey to his theatrical competition, a movie house known as the Esquire that played art films during the 1930s and '40s. Incidentally, it was the rise of motion pictures that lured patrons away from the theater and resulted in Jewett's financial ruin.

So why all this postmortem double toil and trouble? Perhaps the actor's spirit has made a posthumous return to the stage he built in an attempt to support the Huntington's sixty-year stint as a live theatrical venue. The show must go on…and on and on.

File under: Shakespearean specter

Emerson's Cutler Majestic Theatre

When it comes to the grand, turn-of-the-century Emerson's Cutler Majestic Theatre, history has a way of repeating itself. Built in 1903 by Eben Dyer Jordan, the heir of the Jordan Marsh chain, the Beaux Arts–designed theater was lauded as "exceptionally artistic" and "a dream in itself" in an ad featured in the Sunday 2003 edition of the *Boston Globe*. In the 1920s, the structure hosted live theater and vaudeville acts as part of the large Shubert empire. It was converted into a movie theater, with much of its gilded beauty—which included dramatic stained-glass windows and an inverted-bowl design constructed without balcony-supporting columns—hidden from view. In the 1950s, the theater was renamed the Saxon, or the "Sack" for short, and became a run-down remnant of Boston's Combat Zone, an adult entertainment district that attracted peep shows and prostitution. Emerson purchased the "beautiful lady" in 1983 and spent more than $2.5 million to restore the Majestic to its original Beaux Arts glory. "The days of the Combat Zone are over," announced former mayor Raymond Flynn at the reopening of the 1,200-seat theater in the mid-'80s. "Boston's greatest days are yet to come."

While Emerson's Cutler Majestic Theatre was returned to its turn-of-the-century charm, the ghosts from its not-so-Puritanical past reportedly haunt the structure's ornamented interior. Marcia Weaver, in the October 2000 *Boston Herald*, said that workers at the Majestic reported seeing ghostly visions of a man in a tuxedo and a little blonde girl with braids in the upper balcony near the lighting system. "Ghosts seem to be attracted to electricity and energy," Weaver said.

Emerson's Cutler Majestic Theatre was returned to its turn-of-the-century charm, and the ghosts from its past reportedly haunt the structure's ornamented interior. The second balcony—which was closed to the public for years and reopened in May 2003—and the sound area are the source of most of the theater's paranormal activity. *Photo by Ryan Miner.*

Author Christopher Forest, in *Boston's Haunted History*, claimed that multiple spirits haunt the Emerson Cutler Majestic. "Many students who have attended Emerson College and have spent time working in the theater report sensing unearthly and eerie feelings," he wrote. "According to local lore, the spirits of a little girl, a politician, and perhaps even former stage crew and actors have been seen roaming the Majestic."

The lone-ghost politico, a black-shadow entity wearing a gray flannel hat, inhabits the seat of a former mayor who allegedly died at the theater during a performance. The unnamed politician is rumored to be a residual spirit. "Many believe that the mayor reclaims his seat from time to time, coming to take in yet another play before making his own final curtain call," Forest continued.

According to several sources, the second balcony—which was closed to the public for years and reopened in May 2003—and the sound area are the source of most of the theater's paranormal activity. "Back in the day, it was the place where the poor and minority patrons of Boston sat," reported a former Emerson student online. "Seats are often found down when they should be up, and it is tradition for someone to say excuse me if they pass a downed seat because they are blocking the ghost's view. It would take weight to keep them down." The online source said a stagehand noticed one of the unused seats in the upper balcony move mysteriously. "When she went to investigate, she found the dust had cleared on those seats as if someone had been sitting there."

Forest mentioned that four residual apparitions have been spotted in the peanut gallery area. "Technicians have reported talking to a man in the balcony, only to report that he disappears seconds later, when they turn around to face him," he wrote. "Other workers claim to have spotted two adults, and a child, dressed in Victorian clothing sitting in this section, awaiting a performance."

Joseph Mont and Marcia Weaver in *Ghosts of Boston* noticed a correlation between phantoms and the sound area. "Most of the spirits, fortunately, are more playful and curious than malevolent. In particular, they have a fascination with electricity. Students who work the theater's electrical lighting board will, on occasion, come face-to-face with these ghosts," Mont and Weaver mused.

On March 4, 1897, a gas-line explosion at the corner of Tremont and Boylston Streets killed at least six people and injured sixty others. The leak was from a six-inch gas line located beneath the street near the soon-to-be-built theater and above the Tremont subway tracks. A spark from a trolley

car caused the gas to ignite. The explosion caused thousands of windows to shatter, and some believe the psychic imprint left over from the 1897 gas-line explosion is tied to the spirits haunting the Majestic and its neighboring Emerson dorm, The Little Building.

Whether or not the ghosts are tied to the gas-line disaster, Forest contends that a few of the theater's alleged spirits are mischievous poltergeists. "At times, the power in the theater remains on, but the sound shuts off for no apparent reason," he penned. "Typically, this sets off the timing of a performance and can cause general havoc on stage and off. Speculation exists that it's the ghosts causing such mischief and might even be sharing their opinion about the performance. If they don't like the show, they let the players know."

Paranormal investigators like Adam Berry from *Ghost Hunters* strongly believe that poltergeists, or intelligent spirits responsible for physical disturbances like turning lights on and off, aren't bound to a specific location. Perhaps the Cutler Majestic Theatre's ghosts are just stopping in for a show. Workers at the theater treat the spirits as if they're regulars. Also, ushers respect the presence of the unseen entities by not blocking their views on the third-floor balcony.

Christopher Balzano, founder of Massachusetts Paranormal Crossroads, told the *Boston Globe* in 2006 that he's heard of two additional poltergeists haunting the theater. One is the spirit of a janitor who hangs out onstage. Another is the ghost of an elderly female who spends her time in the dressing room. Incidentally, the 1897 gas-line explosion killed a seventy-year-old woman who was burned to death in her private carriage, and a janitor was listed as seriously injured. Coincidence? It's possible.

File under: paranormal playhouse

EVERETT SQUARE THEATRE

Hyde Park's historic Everett Square Theatre has been dormant for more than twenty years. However, according to Scott Trainito, founder of Para-Boston, and Mike Baker, head of the group's scientific unit, NECAPS, the one-hundred-year-old playhouse hasn't been completely abandoned. In fact, Trainito spearheaded a paranormal investigation at the entertainment complex in October 2011 and had a close encounter with an unseen entity.

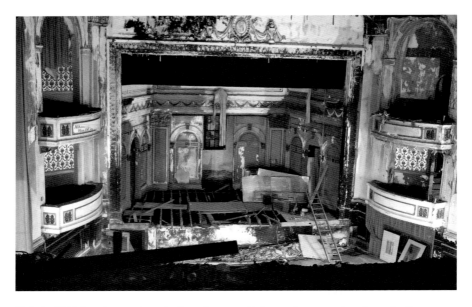

Built in 1915 for plays and musicals and eventually becoming a movie palace, the Everett Square Theatre located at 16 Fairmont Avenue has entertained generations of Hyde Park residents and is reportedly home to a projection-room phantom. *Courtesy of Mike Baker from the New England Center for the Advancement of Paranormal Science (NECAPS).*

"We got breathing, heavy inhaling and exhaling sounds and footsteps that were very clear," Trainito said, adding that his team spent six hours in the run-down theater armed with video-audio recorders and EMF detectors. "They were coming from the projection room, and we knew there was absolutely no one up there. It wasn't a rat or any animal because you can't hear rats breathing. So what was it? That's what we don't know."

Built in 1915 for plays and musicals and eventually becoming a movie palace, the theater located at 16 Fairmont Avenue has entertained generations of Hyde Park residents. During the Depression era, Everett Square became Joseph A. Logan Square, and the playhouse was renamed the Fairmont Theater in 1934. In the 1970s, the space became the Nu-Pixie Cinema and was later called Premiere Performances in the '80s. During its final curtain call, it was an auction house, and the Everett Square Theatre has been closed ever since. As the once-thriving landmark slowly deteriorated into arrested decay, ghost lore stepped up to fill the void.

According to legend, lights were allegedly cut at the Everett Square Theatre during a sold-out show and an entire section of people were slaughtered. The myth suggested that supernatural screams and cries

could be heard coming from the abandoned balcony. Based on Trainito and Baker's research, the grisly back story surrounding the complex isn't true. In fact, they couldn't find any evidence of violence or disaster throughout the theater's century-old history. However, the Para-Boston team did uncover paranormal activity.

"A lot of what you read online about the theater is absolutely false," Trainito told me. "There are several Everett theaters, including one in Washington, and somehow the legends got merged. There's cross-contamination with legitimate online sources that have mixed up the information," Baker added. "We were able to sort through the information by reading original newspaper accounts and found out that there were no official claims of hauntings in the theater…but we did gather evidence while we were there."

During the investigation, the Para-Boston team split into four groups and uncovered several paranormal anomalies. For example, when Baker asked, "Can you move something for us?" in the main theater, the team noted that an unseen force moved a chair. There were also sounds of muted footsteps and then a bang in the stairwell leading up to the projection room. They also recorded the sounds of footsteps and then what sounded like an inhale followed by a harsh exhale inside the room. No one—at least no one living—was in the projection area.

"Based on what we uncovered, there may be a correlation to environmental conditions," Baker noted, adding that the projection room had a high level of electromagnetic fields, which could be explained by faulty electrical wiring. "Electricians will often coil wires up in a circle in the walls," Trainito explained in the *Revere Journal* in October 2011. "That creates a field. It's like living under a huge power line. That electrical energy makes a person hypersensitive and can make them feel like someone's watching them. That's one thing we frequently find."

During the Everett Square Theatre investigation, the team played old-school music in front of the deteriorating stage and tried to conjure up an atmosphere that has been dormant for years. "We played old music, both audibly and through electromagnetic fields, and then we would applaud to see if we could stir up energy that was originally there. Funny thing is that we did find evidence," Baker continued. "It may not be what we were expecting, but it was interesting evidence, like movement in the projection room."

Pat Tierney, the Everett Square Theatre's owner, has spent twenty years trying to renovate the fallen structure, and two months after the Para-Boston investigation in January 2012, she made some major changes by restoring the original 1915 sign. "Growing up in Hyde Park, I can remember this as

the Fairmount Theater," said Mayor Thomas Menino at a press conference outside the building. "Coming here on a Saturday afternoon—and how much did we get then from our parents to come here? Thirty cents. Twenty cents to get in and ten cents for popcorn."

Menino continued, "We preserve the past for the future, so these youngsters can remember some of the things we had in this neighborhood in the past." Armed with a $30,000 grant from the city's Edward Ingersoll Browne Fund, Tierney managed to restore the theater's foyer and replace the historic sign.

Trainito and Baker said the fallen theater is a stunning turn-of-the-century treasure worthy of community support—even if it is haunted. "She's in the process of renovating the theater," Baker explained, alluding to Tierney's passion for spearheading its re-gentrification. "It's a tremendous task because the place is extremely dilapidated but really beautiful. You can picture it in its heyday by spending some time there, but boy, does she have her hands full."

As far as spirits, Para-Boston debunked a majority of the historical inaccuracies, including a supposedly deadly fire and a not-so-true balcony massacre. However, the team may have opened a paranormal version of Pandora's box with its recent investigation. Everett Square Theatre has activity—so it's no surprise that the theater's projection-room phantom has an odd affinity for the cult classic *Night of the Living Dead*.

File under: creep show

SOURCES

The material in this book is drawn from published sources, including issues of the *Boston Globe*, *Daily Globe*, *Boston Herald*, *Boston Phoenix*, *New York Times* and college newspapers like the *Berkeley Beacon*, *Daily Free Press*, *Harvard Crimson* and *The Heights*. Several books on Boston's paranormal history were used and cited throughout the text. Other New England–based websites and periodicals, like *Yankee*, *Boston* and *STUFF* magazines, served as sources. I also conducted firsthand interviews, and some of the material is drawn from my own research. It should be noted that ghost stories are subjective, and I have made a concerted effort to stick to the historical facts, even if it resulted in debunking an alleged encounter with the paranormal.

Boston Fire Historical Society. *Boston's Fire Trail: A Walk Through the City's Fire and Firefighting History*. Edited by Stephanie Schorow. Charleston, SC: The History Press, 2007.

Fiedel, Dorothy Burtz. *Ghosts and Other Mysteries*. Ephrata, PA: Science Press, 1997.

Forest, Christopher. *Boston's Haunted History: Exploring the Ghosts and Graves of Beantown*. Atglen, PA: Schiffer Publishing, 2008.

Hauk, Dennis William. *Haunted Places: The National Directory*. New York: Penguin Group, 1996.

Mont, Joseph, and Marcia Weaver. *Ghosts of Boston*. Boston: Snakehead Press, 2002.

Nadler, Holly Mascott. *Ghosts of Boston Town: Three Centuries of True Hauntings*. Camden, ME: Down East Books, 2002.

Ogden, Tom. *Haunted Theaters: Playhouse Phantoms, Opera House Horrors and Backstage Banshees*. Guilford, CT: Globe Pequot Press, 2009.

Revai, Cheri. *Haunted Massachusetts: Ghosts and Strange Phenomena of the Bay State*. Mechanicsburg, PA: Stackpole Books, 2005.

Rooney, Ashley E. *Cambridge, Massachusetts: Ghosts, Legends & Lore*. Atglen, PA: Schiffer Publishing, 2009.

Rule, Leslie. *When the Ghost Screams: True Stories of Victims Who Haunt*. Kansas City, MO: Andrews McMeel Publishing, 2006.

Schmidt, Jay. *Fort Warren: New England's Most Historic Civil War Site*. Amherst, NH: Unified Business Technologies Press, 2003.

Steitz, George. *Haunted Lighthouses*. Sarasota, FL: Pineapple Press, 2002.

Tucker, Elizabeth. *Haunted Halls: Ghostlore of American College Campuses*. Jackson: University Press of Mississippi, 2007.

Zwicker, Roxie J. *Haunted Pubs of New England: Raising Spirits of the Past*. Charleston, SC: The History Press, 2007.

About the Author

Journalist Sam Baltrusis freelances for various publications, including *Boston Spirit* magazine and *STUFF.* He teaches writing and journalism classes at the Boston Center for Adult Education (BCAE). His blog, "Loaded Gun Boston," is an online destination focusing on the latest crop of made-in-Boston films, showcasing the behind-the-scenes buzz surrounding Hollywood East, as well as the people, places and products featured. As a side gig, he moonlights as a tour guide with Haunted Boston, highlighting the city's historical haunts. In the past, he's worked for VH1, MTV.com, *Newsweek*, WHDH.com, ABC Radio and as a regional stringer for the *New York Times*. Currently living in Somerville's Davis Square, Baltrusis shares a home with a mischievous female spirit with an affinity for sharp objects. He jokingly calls her "Scissor Sister."

While taking a photo in front of the famed "enchanted mirror" on the second-floor mezzanine, author Sam Baltrusis noticed condensation mysteriously appear on the mirror as if someone, or something, was breathing on it. *Photo by Ryan Miner.*

Visit us at
www.historypress.net